The Best of Professional
Digital Photography

BILL HURTER

Amherst Media, Inc. ■ Buffalo, NY

ABOUT THE AUTHOR

Bill Hurter started out in photography in 1972 in Washington, DC, where he was a news photographer. He even covered the political scene—including the Watergate hearings. After graduating with a BA in literature from American University in 1972, he completed training at the Brooks Institute of Photography in 1975. Going on to work at Petersen's PhotoGraphic magazine, he held practically every job except art director. He has been the owner of his own creative agency, shot stock, and worked assignments (including a year or so with the L.A. Dodgers). He has been directly involved in photography for the last thirty years and has seen the revolution in technology. In 1988, Bill was awarded an honorary Masters of Science degree from the Brooks Institute. He has written more than a dozen instructional books for professional photographers and is currently the editor of *Rangefinder* magazine.

Front cover photograph by Yervant Zanazanian.
Back cover photograph by Craig Minielly.

Published by:
Amherst Media, Inc.
P.O. Box 586
Buffalo, N.Y. 14226
Fax: 716-874-4508
www.AmherstMedia.com

Publisher: Craig Alesse
Senior Editor/Production Manager: Michelle Perkins
Assistant Editor: Barbara A. Lynch-Johnt

ISBN: 1-58428-188-X
Library of Congress Card Catalog Number: 2005937370

Printed in Korea.
10 9 8 7 6 5 4 3 2 1

Notice of Disclaimer: The information contained in this book is based on the author's experience and opinions. The author and publisher will not be held liable for the use or misuse of the information in this book.

TABLE OF CONTENTS

ACKNOWLEDGMENTS

As you will see from the photographs throughout this book, the range of creativity and uniqueness displayed by today's top digital photographers is incomparable. I wish to thank the many fine photographers who have contributed to this book—not only for their images, but also for their expertise. As anyone who has investigated the technical aspects of digital beyond a surface level has no doubt discovered, there are contradictions galore and volumes of misinformation surrounding everything digital. It is my hope that throughout this book you will find many of those mysteries unraveled. I also wish to thank the many photographers who shared trade secrets with me for the purposes of illuminating others. Some of their tips, which appear throughout the book, are as ingenious as they are invaluable.

1. THE ADVANTAGES OF DIGITAL CAPTURE

Digital technology is virtually exploding. New cameras with higher resolutions, improved imaging chips, and added functionality are being introduced with ever-greater frequency—as are peripheral products that support digital imaging. Almost without exception, imaging manufacturers' entire research and development budgets are going into digital products. The reason for this sea change in image-making is clear: digital offers contemporary photographers flexibility, speed, and creative control.

■ REDUCED COSTS, INCREASED SHOOTING

Ask any photographer shooting film if he or she mentally inventories the number of exposed and unexposed rolls during a wedding or portrait session and they'll all tell you that they do it. They also mentally calculate the fees of buying, processing, and proofing that film. Not so with digital, where there are no film and processing costs. The net result is that digital photographers shoot many more images at any given event. They can also change from color to black & white on the fly or switch the white balance and film speed from frame to frame. In addition, since digital media now offer multiple gigabytes of storage, today's photographers don't need to spend valuable time on a shoot changing film.

■ INSTANT PREVIEWS

Digital capture also provides the ability to instantly preview images, meaning that if you missed the shot for any reason, you can delete that file and retake it on the spot. Kathleen Hawkins, an acclaimed wedding and children's portrait photographer and the other half of Jeff Hawkins Photography, says, "That kind of insurance is priceless. Think about it—you're photographing the first dance, capturing the couple from all angles and possibly using your assistant to backlight them. You see that the background light is not bright enough or that your on-camera flash misfired. With digital, instead of waiting a week or two to see that you blew it, you can adjust the lighting and move on." These previews also make it possible for the subject or client to examine the captured images instantly, capitalizing on the excitement of the in-progress photo session.

FACING PAGE—Digital capture lets the photographer create a work of art to deliver to the client. Photograph by Jeff Hawkins.

■ ENHANCED CREATIVITY

Photographers are no longer just recording images and sending them off to the lab for color correction, retouching, and printing. Says Kathleen Hawkins, "We can now perfect our art to the fullest extent of our vision!"

Digital has also opened up a wealth of creative opportunities for Connecticut's Charles and Jennifer Maring, transporting them from being merely photographers to the status of artists and graphic designers. Their unique digital wedding albums include an array of beautifully designed pages with graphic elements that shape

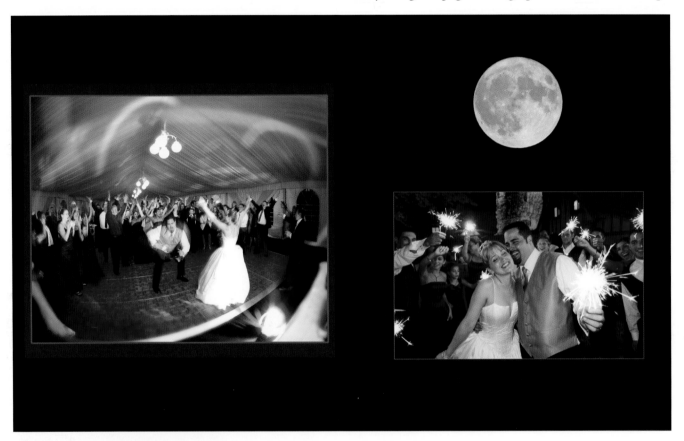

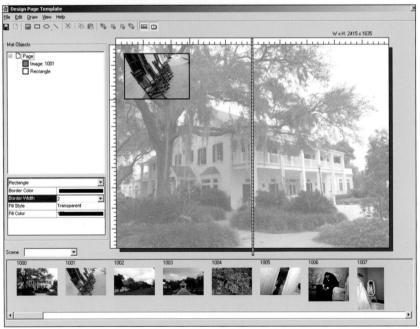

ABOVE—Charles and Jennifer Maring put so much fun and creativity into their wedding albums. Here is a sample page from one of their albums. LEFT—Album design programs, such as Montage allow you to drag and drop images into to template pages for the ultimate ease of design. Because the program doesn't require full-resolution images, proxy images are used instead, the design process is fast and seamless. Images by Kathleen and Jeff Hawkins. FACING PAGE—David Beckstead considers himself more an artist than a photographer and he likes his clients to feel the same way. He is constantly searching for new angles and moments within the wedding day to create striking images that are unique.

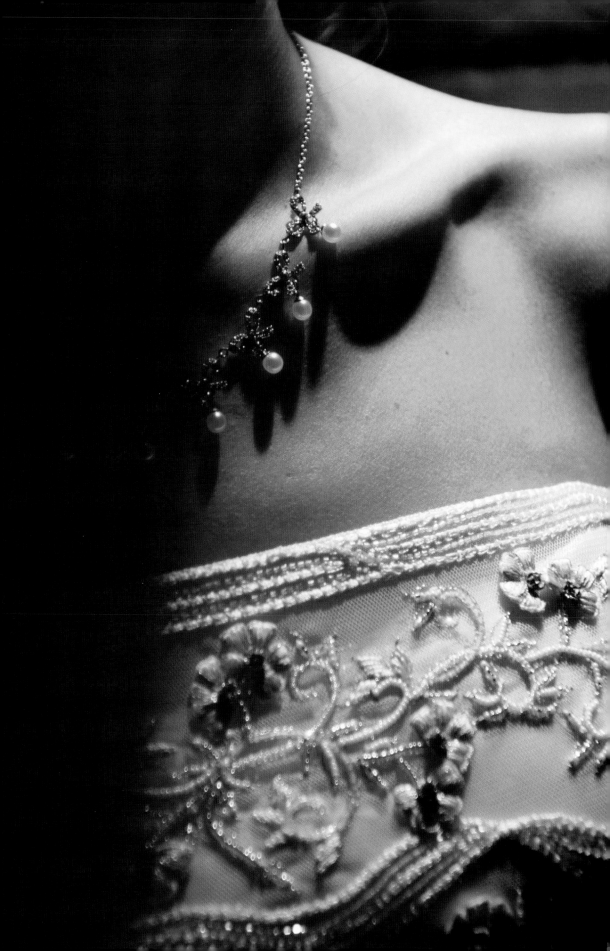

Kersti Malvre uses her scanned and Photoshop-manipulated images in many ways. She will often create a series of 5x7-inch digital portfolios to send to friends and potential clients. The images are printed on velvet paper, mounted on elegant printed card stock with her signature and a message about her artwork, then bound in a folio that she has created for her digital prints.

each page and layout. Their story-telling style is as sleekly designed as the latest issue of *Modern Bride*. The Marings not only work each image but also design each album. Says Charles, "There is a unique feeling when designing the art. I don't know what an image will look like until I am almost done with it. I also don't know where the vision comes from. I relate this to the art of photography. A higher place maybe."

This talented couple believes so totally in controlling the end product that they also own their own digital lab, named R-Lab. "We have been totally digital for quite some time, and the challenge and precision of the change has actually made us better photographers than we were with film," says Charles. He believes the outside of the album is every bit as important to his upscale clients as each page therein, and has been known to use

covers ranging from black leather, to metal, to red iguana skin. He has even found a local bookbinder with his own working bindery for finishing their digital albums.

■ ARCHIVAL PERMANENCE

Another benefit of digital is its archival permanence. Traditional photographic film and prints achieve archival status by having a reduced chemical reactivity of their basic components. In other words, the dyes, pigments, and substrates used in their creation remain stable over time, provided that storage or display conditions are optimal. A digital image, on the other hand, is stable over time and there is no degradation in copying. Every copy is a perfect copy. Multiple copies stored on stable media assure survivability and endurance over time.

■ DIGITAL RETOUCHING

In addition to the above benefits, the daunting task of traditional retouching has been all but eliminated by the ease of retouching in Adobe Photoshop. This has permanently changed the style and scope of professional imagery. Once the exclusive province of accomplished darkroom technicians, special effects are now routinely created by photographers in the comfort of their homes or studios—and with results most people feel far exceed those achieved in a traditional lab or darkroom.

Today's best photographers spend a great deal of time perfecting each and every image that goes out to a client. Perhaps this aspect of contemporary photography, more than any other, has accounted for the profound increase in artistic images. This fine-art approach, in turn, raises the bar financially for such photographers, allowing them to charge premium prices for their sessions. Says photographer David Beckstead, "I treat each and every image as an art piece. If you pay this much attention to the details of the final image, your clients will pick up on this and often replace the word 'photographer' with the word 'artist.'"

■ REMOTE CAPTURE AND WIRELESS TRANSFER

Digital photography is completely interlocked with computer technology and derives many benefits because of it. For instance, commercial photographers often use laptop computers as control stations. Nikon Capture,

> ## TIME AND MONEY
>
> Of course, the many digital advances don't come without at least some cost. One of the biggest complaints of photographers who have gone digital is the long workflow. For many, the money they save in film and processing seems to go right back into expensive digital equipment, computers, and ever-changing technology. Even beyond the expenditures, the time many photographers now spend in front of a computer monitor has drastically increased.

the RAW file processing program for Nikon NEF images, also comes with a program called Nikon Capture Control, which turns the camera into a remote-capture device for the computer. With this software, you can download captured images directly to the laptop, where they can be viewed full screen. This lets clients, on location, view live, in-progress images and make useful comments on the success or failure of the assignment. This is a huge difference from the days of film, where the client would be shown proofs or transparencies hours or days after the job was shot. Creative client input can be put into effect immediately as the assignment progresses. Plus, there is no need for loupes or light boxes—the image is bold and bright on the laptop screen.

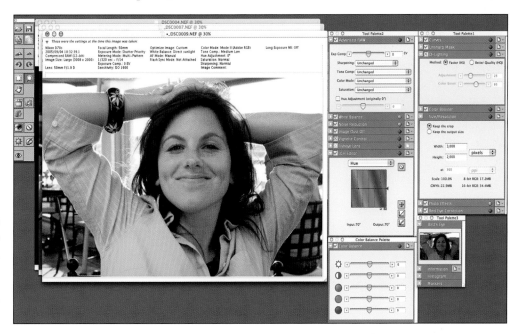

A screen grab from Nikon's Capture image editor shows of the options for changing a RAW image (or in this case NEF—Nikon's name for their RAW format) before processing.

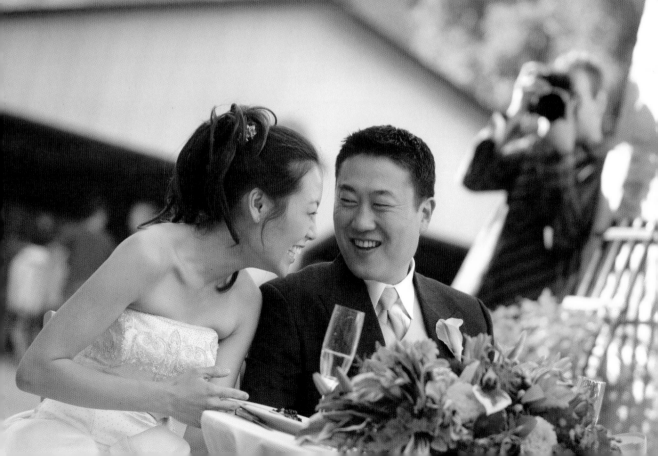

FACING PAGE—Mike Colon is a well known wedding photographer who uses Nikon DSLRs and their WiFi technology to download images to a laptop as they are recorded throughout the wedding day. Mike's assistant preps the images and then saves them into a slide-show program so that guests just entering the reception are greeted with a visual treat. The power of digital imaging has transformed the wedding day into a multimedia event. **ABOVE**—Chris LaLonde uses his G4 PowerBook as an on-site monitor when shooting assignments. This lets Chris and his clients inspect the photos at close range. If the layout calls for a specifically shaped photo, Chris will create a black matte mask to tape into position on the monitor.

Another remarkable feature of digital photography is the wireless transmission of images, otherwise known as WiFi technology. With a wireless transmitter, it's possible to transmit images directly from the camera over a wireless LAN (local area network). Nikon's Wireless Transmitter WT-2A allows photographers to transmit images over a WiFi network *and* use wireless remote control of the camera over a WiFi network from a computer running Nikon Capture software (as in the tethered application above). This lets photographers position their cameras in places that may be inaccessible or restricted to photographers, then wirelessly adjust settings, trigger the camera, and instantly retrieve the images over the LAN. With this technology, events like the space-shuttle launches, where security is unforgiving, can now be accessed remotely. The latest versions

DON'T GET CAUGHT UP WITH THE TOOLS

It is easy to get caught up in the hardware and software of digital photography. It is expensive, exotic, and amazingly productive. Yervant Zanazanian, an award-winning Australian photographer, puts this in perspective. "A lot of photographers still think it is my tools (digital capture and Photoshop) that make my images what they are. They forget the fact that these are only new tools; image-making is in the eye, in the mind, and in the heart of a good photographer. During all my talks and presentations, I always remind the audience that you have to be a good photographer first. You can't expect or rely on some modern tool or technology to fix a bad image." It's good advice.

Yervant, like Charles Maring, is an expert album designer and even has a line of album page templates available (www.yervant.com) called Page Gallery for designing album pages in Photoshop.

of this software also feature drastically improved transmission times and highly refined security protocols, making it nearly impossible for someone to intercept the transmission.

The Internet also plays a huge role in the life of the digital wedding photographer. Online proofing and sales have become a big part of every event package. Bridal couples can check out "the take" of images while on their honeymoon by going to the photographer's web site and entering their own unique password—all from the comfort of their hotel room or a digital café. The use of FTP (file transfer protocol) sites for transferring files to the lab for proofing and or printing has now become routine.

The days of medium-format cameras being used exclusively for fine photography seem to be at an end. Fast, versatile zoom lenses, cameras that operate at burst rates of 6 frames-per-second, amazingly accurate autofocus lens performance, and incredible developments in digital imaging technology have led to the 35mm DSLR (digital single-lens reflex) becoming the camera system of choice for today's top professional photographers.

Professional 35mm digital camera systems include a full array of lenses, dedicated TTL flash units, and system accessories. Currently, there are seven companies manufacturing full-fledged DSLR systems: Canon, Nikon, Olympus, Fuji (which uses Nikon autofocus lenses), Pentax, Konica/Minolta, and Sigma (which uses the radically different Foveon X3 image sensor). Each manufacturer has several models within their product line to meet varying price points. Many of the pre-digital lenses available from these same manufacturers for their film cameras also fit the new digital cameras (although often with a corresponding change in focal length). In addition, a number of third-party lens manufacturers also make AF lenses to fit various brands of DSLRs. These include Tokina, Tamron, and Sigma.

Since the advent of the DSLR, manufacturers are investing huge sums into product development and engineering and more advanced, less expensive camera models are appearing every day.

■ ZOOM LENSES VS. PRIME LENSES

Zoom Lenses. For today's digital photographer, one of the most popular lenses for all types of photography seems to be the 80–200mm f/2.8 (Nikon) and 70–200mm f/2.8 (Nikon and Canon). These are very fast, lightweight lenses that offer a wide variety of useful focal lengths for many applications. This makes them particularly popular among wedding photographers,

FOCAL-LENGTH FACTORS

Since all but full-frame DSLRs have chip sizes smaller than 24x36mm (the size of a 35mm film frame), there is a magnification factor that changes the effective focal length of the lens. For instance, Nikon DSLRs have a 1.5X focal-length factor that makes a 50mm f/1.4 lens a 75mm f/1.4 lens—an ideal portrait lens. This does not affect the lens speed.

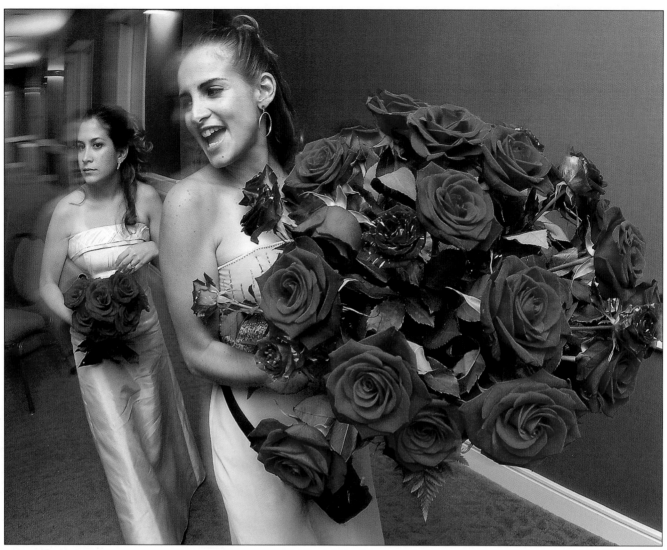

Here, Jeff Kolodny used a 10.5mm f/2.8G ED AF DX Fisheye-Nikkor lens on a Fujifilm FinePix S2 Pro camera to create a wonderful wide-angle effect. Notice that the roses, very close to the lens, look huge, while other aspects of the scene recede in size quite dramatically. This is a normal fisheye lens effect that is exaggerated the closer objects are to the camera. The 10mm Nikkor lens is designed for digital imaging and produces the effect of a 15mm fisheye lens with the smaller size imaging chip on the Fujifilm FinePix S2 Pro. Jeff used bounce flash to freeze the bridesmaids and captured the scene at ⅛ second at f/6.7 with an ISO of 800.

who find them useful for all phases of the ceremony and reception. They are also internal focusing, meaning that autofocus is lightning fast and the lens does not change its physical length as it is focused. At the shortest range, 80mm (or 70mm), these lenses are perfect for full- and three-quarter-length portraits. At the long end, the 200mm setting is ideal for tightly cropped candid coverage or head-and-shoulders portraits. These zoom lenses also feature fixed maximum apertures, which do not change as the lens is zoomed. This is a prerequisite for any lens to be used in fast-changing conditions. Lenses with variable maximum apertures provide a cost savings but are not as functional nor as bright in the viewfinder as a faster, fixed-aperture lenses.

Wide-angle lenses are also popular—both fixed focal-length lenses and wide-angle zooms. Focal lengths from 17mm to 35mm are ideal for capturing atmosphere as well as for photographing larger groups.

Because digital lenses do not have to produce as wide a circle of coverage as lenses designed for full-frame chips, lens manufacturers have been able to come up with some splendid long-range zooms that cover wide-angle to telephoto focal lengths. Lenses like Canon's EF 28–300mm f/3.5–5.6L IS USM and EF

28–200mm f/3.5–5.6 USM are fast, lightweight, and extremely versatile given the extreme range of focal lengths covered.

Prime Lenses. Fast, fixed focal-length (prime) lenses (f/2.8, f/2, f/1.8, f/1.4, f/1.2, etc.) will get lots of use, as they afford many more "available light" opportunities than slower speed lenses. Anytime you can avoid using flash, which naturally calls attention to itself, you should generally do so. Additionally, although modern zoom lenses, particularly those designed for digital SLRs, are extremely sharp, many photographers insist that a multipurpose lens cannot possibly be as sharp as a prime lens, which is optimized for use at a single focal length.

Mike Colón, a talented photographer from the San Diego area, uses prime lenses (not zooms) in his wedding coverage and shoots at wide-open apertures most of the time to minimize background distractions. He says, "The telephoto lens is my first choice, because it allows me to be far enough away to avoid drawing attention to myself but close enough to clearly capture the moment. Wide-angle lenses, however, are great for shooting from the hip. I can grab unexpected moments all around me without even looking through the lens."

Wedding photographer Jeff Kolodny uses a Canon EOS 1Ds Mark II DSLR. This image was recorded with an EF 70–200mm f/4L USM lens at the 70mm setting. He used a 1000-speed ISO setting and exposed the image at $^1/_{40}$ second at f/7 to extend the minimal depth of field at this close-focus setting. Because the 1Ds Mark II uses a full-size imaging chip (the same size as a 35mm film frame), there is no focal-length factor; a 70mm setting is 70mm.

FACING PAGE—Mike Colón prefers prime lenses. One of the best kept secrets is the standard lens, in this case a 50mm f/1.4, which becomes a 75mm f/1.4 on the Nikon D1X. This image, shot wide open, reveals very shallow depth of field and high image sharpness and contrast. **RIGHT**—The short telephoto, here a 135mm f/2, produces beautifully soft blended backgrounds when shot wide open. The photographer, Mike Colón, made this image at $\frac{1}{60}$ second at f/2.8 with the 135mm f/2D AF DC-Nikkor and his D1X.

◼ TELEPHOTO LENSES

Many photojournalists use ultra-fast telephotos, like the 300mm f/2.8 or f/3.5 lenses. These lenses, while heavy and often requiring a monopod for prolonged use, are ideal for working unobserved and they can help isolate some wonderful moments. Even more than the 80–200mm lens, the 300mm throws backgrounds beautifully out of focus. When used wide open at a relatively close camera-to-subject distance, the 300mm provides a delicately thin band of focus, which is ideal for isolating image details.

Another favorite lens is the 85mm (f/1.2 for Canon; f/1.4 or f/1.8 for Nikon), which is a short telephoto with exceptional sharpness. This lens gets used frequently because of its speed and ability to throw backgrounds out of focus, depending on the subject-to-camera distance. Because it produces exceptional image contrast, the difference between in-focus and out-of-focus areas appears much more distinct, thus exaggerating the effects of shooting wide open.

◼ AF TECHNOLOGY

Autofocus, once unreliable and unpredictable, is now extremely advanced. Some cameras feature multiple-area autofocus so that you can, with a touch of a thumbwheel, change the AF sensor area to different areas of

the viewfinder (the center or outer quadrants). This allows you to "de-center" your images for more dynamic compositions. Once accustomed to quickly changing the AF area, this feature becomes an extension of the photographer's technique.

Using autofocus with moving subjects used to be an almost insurmountable problem. While you could predict the rate of movement and focus accordingly, the earliest AF systems could not. Now, however, almost all AF systems use a form of predictive autofocus, meaning that the system senses the speed and direction of the movement of the main subject and reacts by tracking the focus of the moving subject. This is an ideal feature for wedding photojournalism, where the action can be highly unpredictable.

A new addition to autofocus technology is dense multi-sensor area AF, in which an array of AF sensor zones (up to 45 at this writing) are densely packed with-

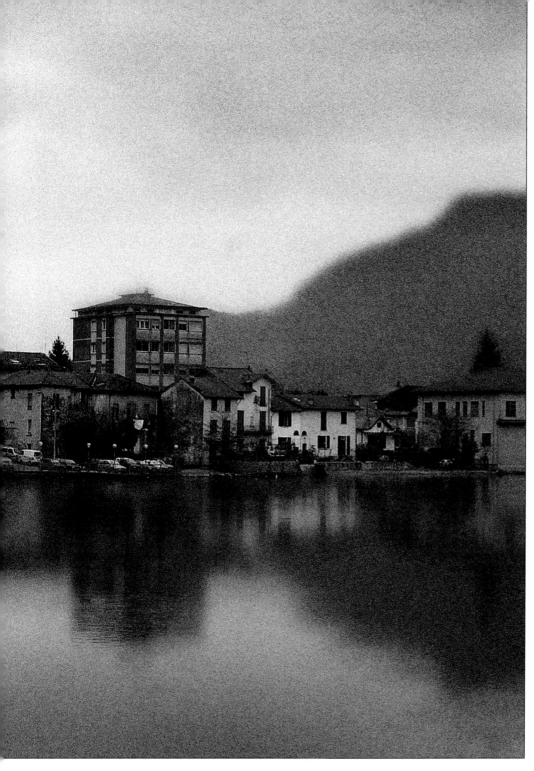

Drake Busath is a gifted photographer who happens to love Italy and teaches workshops there quite regularly. This image was made in Portofino and exemplifies why photographers love digital. The late-day image was photographed normally, but the hillsides were softened so that the town stood out against them. This would be physically impossible given that the hillsides are at infinity and the softness does not precede the area of sharp focus. However, in Photoshop a different reality is available. Grain/noise was added to give the final image a Pointillistic rendition.

in the frame, making precision focusing much faster and more accurate. These AF zones are user selectable or can all be activated at the same time for the fastest AF operation.

■ REMOVABLE STORAGE MEDIA

Types of Media. Instead of film, digital cameras store and save digital image files on portable digital media, such as CompactFlash (CF) cards, Memory Sticks, microdrives, and xD cards. The camera writes the image data to the removable storage device as photographs are captured. When the media becomes full, you eject it and insert a new card or microdrive just like you would change film at the end of the roll. Removable media are rated and priced according to storage capacity—the more storage capacity, the higher the price.

There are two types of media: flash memory (like CF cards and Memory Sticks) and microdrives (miniature

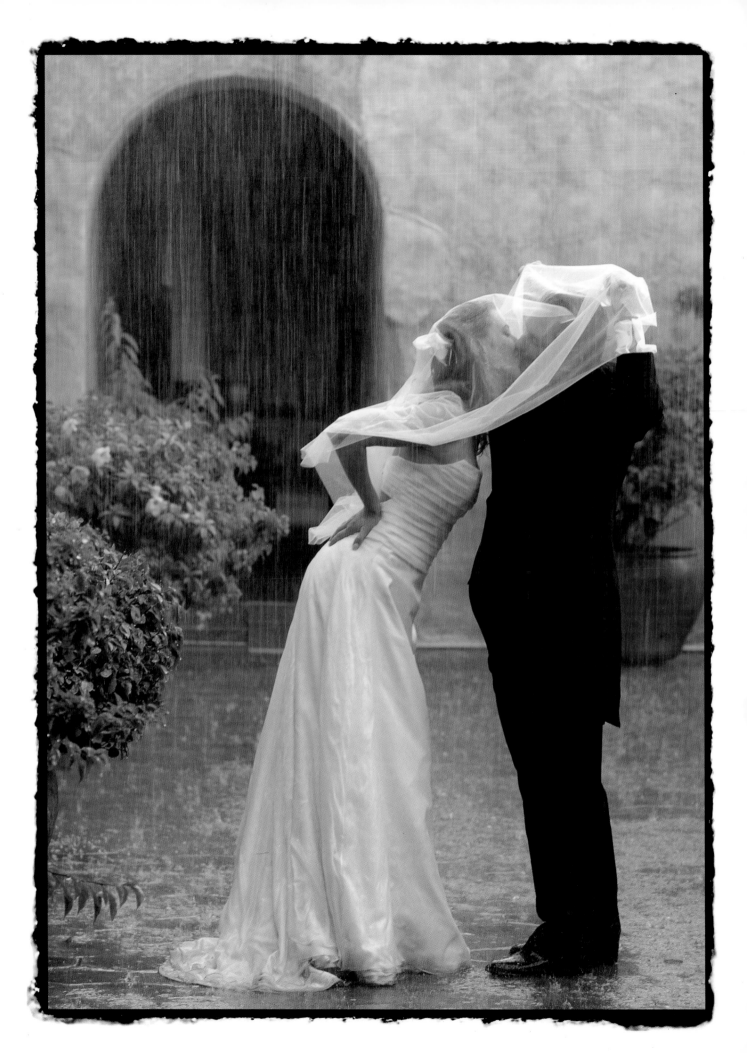

FACING PAGE—No, it really is raining that hard. Wedding photographer Joe Buissink kept coaxing his bride to make the picture, acknowledging the oncoming storm. When she finally acquiesced, it was pouring but the moment was by no means spoiled. Joe helped enhance the feeling of pouring rain by using an 85mm f/1.4D AF Nikkor on his Nikon D2H. A shutter speed of $\frac{1}{60}$ second was used so that the rain would have slight motion to it. ABOVE—A scene from a fishing village in Burano, Italy, is truly representative of the artistic freedom that digital capture allows. The bright, posterized color of the fishing boats contrasts with the muted monochrome sky reflected in the water. A wide-angle lens makes the scene intimate and strong. The image was made by Drake Busath with a Nikon D2H and Nikon wide-angle zoom lens.

portable hard drives). Flash memory, which uses no moveable parts, tends to perform better than mechanical hard drives under adverse shooting conditions. Some cameras feature dual slots for different media types, others accept only a single type of card. Obviously, the more options you have, the more flexible the camera will be over time. The most common formats at this time seem to be the CF cards (Types I and II) and microdrives.

Write Speeds. The write speeds of the different media (how fast data can be recorded by the card) vary from 1.8MB/s (megabytes per second) all the way up to 10MB/s. Write speed is a critical function, especially if you plan to shoot RAW files, which are inherently bulkier than JPEGs. However, the write speed of the

media is not the only determining factor in how fast information will write from the camera to the storage media. The software used by the camera, the file size,

XD CARDS

The latest memory card at this writing is the xD card, developed jointly by Fuji and Olympus. The xD card, which uses NAND Flash memory, is very small and provides write speeds up to 3MB per second. Currently, the largest capacity xD card is 512MB, but by the time you read this, it will be up to 8 gigabytes. Various adapters make the cards useable across a wide range of digital cameras.

Mark Cafiero captured this wonderful faraway moment at a wedding reception with his Canon EOS 1D Mark II (which uses a full-size 16.7MP CMOS image sensor), a 70–200mm f/2.8 zoom lens, and bounce flash. This combination is ideal for weddings where you can work unobserved from a distance. To the naked eye there is no discernable difference between the CMOS and CCD sensors.

and the number of individual files to be written are all determining factors. However, as the crow flies, faster write speed is a desirable quality in storage cards.

Card Readers. Digital images must be uploaded from the removable storage media to a computer. To facilitate this process, a number of digital card readers are available very inexpensively. Of course, the camera can be connected directly to the computer and the images uploaded in this manner, but a card reader gives the photographer the flexibility of putting the camera back into action immediately—loaded with a fresh card. Card readers feature USB 2.0 or FireWire connectivity, which make uploading incredibly fast. Once the images are safely stored on the computer's hard drive and safely backed up on CD or DVD, the memory card can be erased, reformatted, and reused.

■ IMAGE SENSORS

CCD vs. CMOS. Digital cameras use image sensors to record images. Presently there are two main types: CCD and CMOS sensors. While opinions on the aesthetic performance of the two imaging chips vary from pro to pro, both sensor types provide excellent quality image files.

CCDs (charge-coupled devices) record an image in black and white, then pass the light through an array of red, green, and blue filters (called a Bayer filter pattern) to form a color image. Each filter lets only one wavelength of light—red, green, or blue—pass through to any given imaging site (pixel), allowing it to record only one color.

Like CCDs, CMOS imaging chips (complementary metal oxide semicon-

ductors) use a Bayer filter pattern over the photodetectors. Also included on the CMOS imaging chip, however, is analog signal-processing circuitry that collects and interprets signals generated by the photodiode array. After an image has been obtained, it is amplified and converted into standard red, green, and blue (RGB) format through interpolation systems. CMOS chips are more energy-efficient than CCDs, an important consideration as digital cameras are big-time battery consumers. They are also somewhat less expensive to manufacture.

Sensor Size. Although full-frame image sensors now exist, most imaging sensors are smaller than the full 35mm frame size (24x36mm). While the chip size does not necessarily affect image quality or file size, it does change the effective focal length of existing lenses. With sensors smaller than 24x36mm, all lenses get effectively longer in focal length. This is not usually a problem where telephotos and telephoto zooms are concerned,

as the maximum aperture of the lens doesn't change. When your expensive wide-angles or wide-angle zooms become significantly less wide on the digital camera body, however, it can be disconcerting. A 17mm lens, for example, with a 1.4X lens focal-length factor becomes a 24mm lens.

At this writing, there are two camps: manufacturers who believe full-size sensors are the way to go, and those who believe a smaller sensor is more efficient, cheaper to manufacture, and just as reliable—even if there *is* an effective focal-length magnification. Canon's flagship EOS 1Ds is one of the few full-frame chips still available, but the remainder of Canon's DSLR line uses smaller size chips. Nikon's top-of-the-line D2X also uses a smaller chip (22.7x15.7mm), creating a 1.5X focal-length factor.

Camera manufacturers who have committed to the smaller image sensor sizes have begun to introduce lens lines specifically designed for digital imaging. The circle

Mark Cafiero made this wonderful image of the parents on the dance floor with his Canon EOS 1Ds. This camera uses a full-frame image sensor, so there is no focal-length factor. The image was shot with a 70–200mm f/2.8 zoom lens at the 153mm setting.

Most photographers agree that digital file capture is sharper than film capture. Perhaps that is because there is no medium, like film with its three imaging layers, to degrade the lens's sharpness. Another reason for digital's sharpness might be that, with digital lenses and smaller imaging chips, the light being transmitted to the lens is more collimated (in line, like water falling into a bucket). This optimizes the recording of the image at the photodetector sites. Photograph by Ron Capobianco.

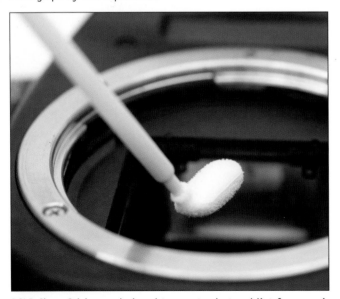

DSLR Clean Sticks are designed to remove dust and lint from sensitive DSLR image sensors.

of coverage (the area of focused light falling on the film plane or digital-imaging chip) is smaller and more collimated to compensate for the smaller chip size. Thus, the lenses can be made more economically and smaller in size, yet still offer as wide a range of focal lengths as traditional lenses.

A Clean Image Sensor. Unlike film cameras, the image sensor in a digital camera must be kept clean of dust and other foreign matter in order for it to perform to its optimum level. Depending on the environment where you do most of your shooting, spots may appear on your images. Cleaning the sensor prior to every shoot will help you to minimize or eliminate such spots in your photos.

While each camera manufacturer has different recommendations for cleaning the sensor, Canon digital cameras have a sensor-cleaning mode to which the camera can be set. With the camera's reflex mirror up (a function of the cleaning-mode setting), the company recommends light air from an air syringe to gently remove any foreign matter. Turning the camera off resets the mirror.

One should realize the image sensor is an extremely delicate device. Do not use propelled air cans, which have airborne propellants that can coat the sensor in a fine mist, worsening the situation.

Intemos (www.intemos.com) markets a liquid-free cleaning product that removes dust and lint from the camera sensor. Lint-free tips with hundred of micropores, called DSLR Clean Sticks, gently clean a sensor's sensitive surface with a delicate vacuum effect that lifts and traps the unwanted dust. Clean Sticks work with both CCD and CMOS sensors.

■ THINGS TO CONSIDER WHEN PURCHASING A DSLR SYSTEM

In no particular order, here are some things to consider when purchasing a digital SLR system.

Sensitivity/ISO Range. Most digital camera systems feature a sensitivity range from ISO 100 to 800 or, in some cases, 1600. Some cameras also offer an ISO 3200 setting as a special custom function. Obviously, the wider the range of sensitivity, the more useful the camera system will be under a wider variety of shooting conditions.

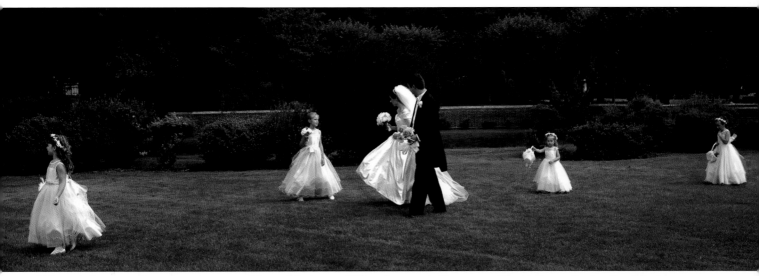

Wide-angle lenses produce expansive compositions with the possibility of a story-telling composition that runs the length of the frame—especially when, as here, the image is cropped to a panoramic format. Ron Capobianco made this image with his Nikon D100 and 24mm lens.

Burst Rate. Unlike film cameras, which use a motor drive to propel the film past the focal plane, there is no film-transport system in a DSLR. The number of frames per second (FPS) the camera can record is dictated by a number of factors, including write speed (how fast the image can be written to the storage media), file type, buffer size, and file size. RAW files are larger than JPEGs, for example, and take longer to record, thus the burst rate is slower when shooting RAW files than it is when shooting JPEGs. Typical burst rates range from 2.5fps (frames per second) for up to six shots, all the way up to 8fps for up to 40 shots. The spec to look at is the number of consecutive frames that can be captured in a single burst (6, 8, 10, etc.) and the frames-per-second rate (3fps up to 8fps).

LCD Monitor. The size and resolution of the camera's LCD screen are important as these screens are highly useful in determining if you got the shot or not. LCD screens range from about 1.8 inches to 2.5 inches and screen resolutions range from around 120,000 to 220,000 dots.

Playback. As important as the physical specifications of the LCD is the number of playback options available. Some systems let you zoom in on the image to inspect details. Some let you navigate across the image to check different areas of the frame in close-up mode. Some camera systems allow you a thumbnail or proof-sheet review of exposed frames. Some of the more sophisticated systems offer a histogram (to gauge exposure) and highlight-point display to determine if the highlight exposure is accurate or "clipped" (i.e. detail is lost in the brighter highlights).

Lens Conversion Factor. The rated focal length of the lens multiplied by the focal-length factor gives the effective focal length. With a 1.6X focal-length factor, for example, a 50mm lens would become an 80mm lens. (*Note:* Lens speed, as mentioned above, is not affected by this conversion. Your f/1.8 lens would still remain an f/1.8 lens.)

Effective Pixels. This is the maximum image size the sensor can record. The spec might be given as 5 million pixels or 5MP (megapixels). Obviously, the higher

BACKUP AND EMERGENCY EQUIPMENT

Most seasoned professionals carry backups and double-backups—extra camera bodies, flash units, transmitters, tons of batteries and cords, double the anticipated number of memory storage cards, and so on. In addition, if using AC-powered flash, extension cords, duct tape (for taping cords to the floor), power strips, flash tubes, and modeling lights need to be backed up. An emergency tool kit is also a good idea, as is a stepladder for photographing large groups or producing an overall shot.

Some photographers prefer to leave their camera settings at minimal contrast and sharpness so that these tasks can be more sensitively applied in Photoshop after the image is saved. Here, Joe Buissink captured the image in JPEG mode at the "hard" sharpness setting on his Nikon D2H with an 80–200mm f/2.8D ED AF Zoom-Nikkor.

the number of pixels, the larger the file; the larger the file, the larger the print you can create from it. Some manufacturers also give the spec in terms of Photoshop file sizes—11MB (megabytes) or 18MB TIFFs, for example, since many people think in these terms. It is important to note that some manufacturers use processing algorithms to interpolate resolution. For example, the chip size might be 6MP, yet the standard file size is 12MP because of the software interpolation.

File Types. The different types of files that DSLRs typically record are RAW files, JPEGs, and TIFF files. JPEGs allow you to shoot more quickly because there is file compression inherent in the format. RAW files provide the maximum amount of information in the captured image.

PC Terminal. Some of the lower-priced DSLRs might seem a bargain until you realize they don't include professional features like a PC terminal for connecting to electronic studio flash.

Shutter-Lag Time. This is a spec most camera manufacturers don't provide in their literature, but is important to know before making a purchase. This is the length of time between when you press the shutter release and when the camera actually fires. Consumer and prosumer cameras (consumer cameras with professional features) have substantially longer shutter-response times than professional systems, which are almost instantaneous, but it is still worthwhile testing out each camera in various modes to see the differences between models. Shutter-lag time will directly affect the

camera's burst rate. Rates of shutter-release delay time are usually given in milliseconds (thousands of a second) if the spec is even given. An average shutter lag time would be in the area of 90ms.

Lens Capability and Accessories. If you're like most professionals, you've already invested heavily in one 35mm SLR system. Convincing you to trade in all those lenses and accessories and change to a different brand of camera would take some compelling arguments. Will your current lenses fit the DSLR and will all of their features be useable on the digital camera body? Know the answers to these questions before you invest.

Removable Media. Some cameras feature dual slots for different media types, others accept only certain types of removable cards, like CompactFlash cards. Obviously, the more options you have to use larger and or less expensive media, the more flexible the camera will be over time.

Dimensions/Weight. As with any camera system, ergonomics are extremely important—especially to the wedding photographer, who will be working for hours on end handholding the camera with a variety of lenses. Try the camera out. It might be quite different than even your same-brand film camera.

Battery Power. So, where's the motor drive? It's been turned into a battery pack. Since you don't need motorized film transport, there is no motor drive or winder, but the cameras still look the same because the manufacturers have smartly designed the auxiliary battery packs to look just like a motor or winder attachment. While most of these cameras run on AA batteries, it is advisable to purchase the auxiliary battery packs, since most digital camera systems (especially those with CCD sensors) chew up AAs like jelly beans. Most of the auxiliary battery packs used on DSLRs use rechargeable Lithium-ion batteries.

Price. It's not necessarily the price of the flagship camera in a manufacturer's product lineup that's important, but rather it's the range of prices. Many photogra-phers have decided to purchase several top-of-the-line DSLRs and then several of the lower-priced models from the same manufacturer for backup and assistants' cameras. These backups still take the same lenses and removable media cards, but are less expensive than the top-of-the-line cameras.

White Balance. White balance determines the color balance of the recorded image. It can be set individually for each series of shots you make (like applying a color-correction filter). Some manufacturers offer a wide range of white-balance options that correspond to a range of Kelvin degree (the color temperature of light) settings. Others use more photographer-friendly terms like "afternoon shade." In addition, virtually all of the cameras feature an automatic white-balance setting, which allows the camera to sense and determine the optimal white-balance setting. Most also include settings for fluorescent and incandescent lighting. Custom functions allow you to create your own unique white-balance settings to correspond to certain known shooting conditions or mixed light conditions. Obviously, the more flexibility you have in accurate white-balance recording, the less color correction you will have to perform later in Photoshop. Some camera systems even offer a white-balance bracketing feature.

A NOTE ABOUT SPARE BATTERIES

As was mentioned above, DSLRs go through batteries rather quickly. While you may bring along extra memory cards, the real essential backup item is spare battery packs. Even with quick-chargers, you will miss precious photo opportunities if you are waiting around for the battery pack to charge. Spare packs should be fully charged and ready to go and you should have enough to handle your cameras, your assistants' cameras, and the backup gear, as well.

3. LIGHTING EQUIPMENT

While there are many types of high-intensity lights designed for photography, most professional photographers choose to work with strobe: electronic studio flash. Strobes are cool-working, portable, and run on household current.

■ STUDIO STROBE SYSTEMS

Types. Studio strobes come in two types: monolights and power-pack kits. Monolights are self-contained; simply plug one into a household AC socket and you're ready to go. Monolights contain light triggers, commonly called slaves, which fire the strobe when they sense the light of another electronic flash. These can be used very far apart and are ideal for location lighting or large rooms.

Power-pack systems accept multiple strobe heads—up to four individual heads can usually be plugged into a moderately priced power pack. Power pack strobes are most often used in studios, since you cannot place the individual lights more than about 20–25 feet from the power pack. Power pack outlets are usually divided into two channels, each with variable power settings that provide either symmetrical or asymmetrical output that can be distributed between one, two, three, or four flash heads.

Studio strobe systems use self-contained modeling lights that are usually dimmable quartz-halogen bulbs that mimic the light of the surrounding flash tube.

Firing Studio Strobes. Studio strobes must be triggered by the camera to fire at the instant the shutter curtain is open. This is often accomplished with a sync cord that runs from the camera's PC connection to the power pack or to one of the monolights (which subsequently triggers all the other monolights that are plugged in and ready to fire). Another means of firing strobes remotely is with radio remote-control devices, which use a digital radio signal to trip the auxiliary strobes at the instant of exposure.

What to Look For. Things to look for in a professional studio strobe system are:

Power. Strobe systems are rated in watt-seconds (W/S); the more W/S, the more light output. The output rating of the power pack means that the total W/S is divided by the number of flash heads in use.

Flash Duration. Short flash durations range from $1/800$ to about $1/12,000$ second. The longer the flash duration, the less action-stopping ability the system has and the

more likely it becomes that exposures may be influenced by existing light.

Recycle Times. Recycle times range from 2 seconds down to less than ¼ second. The faster the recycling time, the faster you can make consecutive full-power exposures.

Modeling Lights. Proportional modeling lights are a necessity, so that each light can be made to closely re-

Clay Blackmore used strobes mounted around the perimeter of this room to light this large wedding reception. Although labor intensive and technically complex, such setups are the only way to shoot surprise moments which happen during the wedding day. To have photographed this scene with straight flash from the camera position would have ruined the spontaneity of the scene and turned the background to black because of light falloff.

semble the output of the individual flash tube. Without accurate modeling lights, it is impossible to achieve precise lighting effects.

Color Temperature. Consistent color-temperature output is a must-have feature—especially when shooting digital JPEGs. Some strobe systems' color temperature output will vary depending on the recycle rate, causing uneven exposures and color-correction problems. Variable color-temperature settings are available on some systems, which can be adjusted in 50°K intervals for consistently warmer or cooler output. These systems will not fire until the units are fully recharged, making consistent color temperature possible.

Fan-Cooled Generator. Power-pack systems have a tendency to overheat and will often require an internal fan to cool the electronics.

Multi-Voltage Capability. This feature allows the strobe system to be used in different countries with different power systems. Often, this is an automatic, self-seeking function that the photographer never even has to worry about.

Computer Control. Some of the recently introduced systems offer a computer interface so that settings can be changed from a laptop or PDA—an invaluable feature for remote applications.

Open-Flash Function. The open-flash control fires the flash manually in the predetermined configuration. It is ideal for open-shutter multiple pops, which are often used with the camera shutter open to build up successive flash exposures to achieve a given f-stop for depth-of-field needs.

Heads and Accessories. The wider the range of available flash heads, accessories, and light modifiers, the more useful the system.

Variations and Accessories. Here are some variations in strobes and the accessories used to modify the quality and quantity of light output.

Barebulb. When the reflector is removed from the flash head, you effectively have a barebulb light source. The light scatters in every direction—360 degrees. Removing the reflector has advantages if you have to place a light in a confined area. Some photographers use a barebulb flash as a background light for a portrait setting, positioning the light on a small floor stand directly behind the subject. Barebulb heads are also used inside softboxes, light boxes, and strip lights for the maximum light spray inside the diffusing device.

Barebulb units with an upright mounted flash tube sealed for protection in a plastic housing are one of the most frequently used handheld flash units at weddings. This is because the 360-degree light coverage means that you can use all of your wide-angle lenses. One popular unit is the Dyna-Lite NE-1 flash, which has a 1000 watt-second pencil-style flash tube. This great location lighting tool is compact and lightweight and can literally fit in your pocket. These light sources act more like large point-source lights than small portable flashes. Light falloff is less than with other handheld units, and they are ideal for flash-fill situations, particularly outdoors. These are predominantly manual flash units, meaning that you must adjust their intensity by changing the flash-to-subject distance or by adjusting the flash

The Profoto Stick Light is a barebulb head that is designed to be placed in hard-to-light areas, such as under furniture or in the corner of a room. It features a long cord so it can be positioned a good distance from the power pack. It doesn't have a housing or reflector, allowing it to be taped down or laid into position easily.

Barebulb flash is a mainstay of outdoor portrait photographers. Here, the late-afternoon sun defines the lighting pattern and the portable, battery-operated barebulb flash fills in the shadows created by the sun. Barebulb flash fires in all directions and allows you to use wide-angle lenses with full flash coverage. The eyes of the senior subject have been retouched to create a single catchlight to better define the lighting pattern. Photograph by Leslie McIntosh.

output. At weddings, many photographers mount a sequence of barebulb flash units on light stands (using ball-head adapters to fine-tune the placement of the light) for doing candids on the dance floor.

Barn Doors. These are black, metal, adjustable flaps that can be opened or closed to control the width of the beam of the light. Barn doors ensure that you light only the parts of the scene you want lighted. They also keep stray light off the camera lens, which can cause lens flare.

Diffusers. A diffuser is nothing more than piece of frosted plastic or acetate in a frame or screen that mounts to the perimeter of the lamp's metal reflector. A diffuser turns a parabolic-equipped light into a flood light with a broader, more diffused light pattern. When using a diffuser over a light, make sure there is sufficient room between the diffuser and the reflector to allow heat to escape. (*Note:* This is even more important with hot lights than with strobes.) The light should also have barn doors attached. As with all lights, they can be

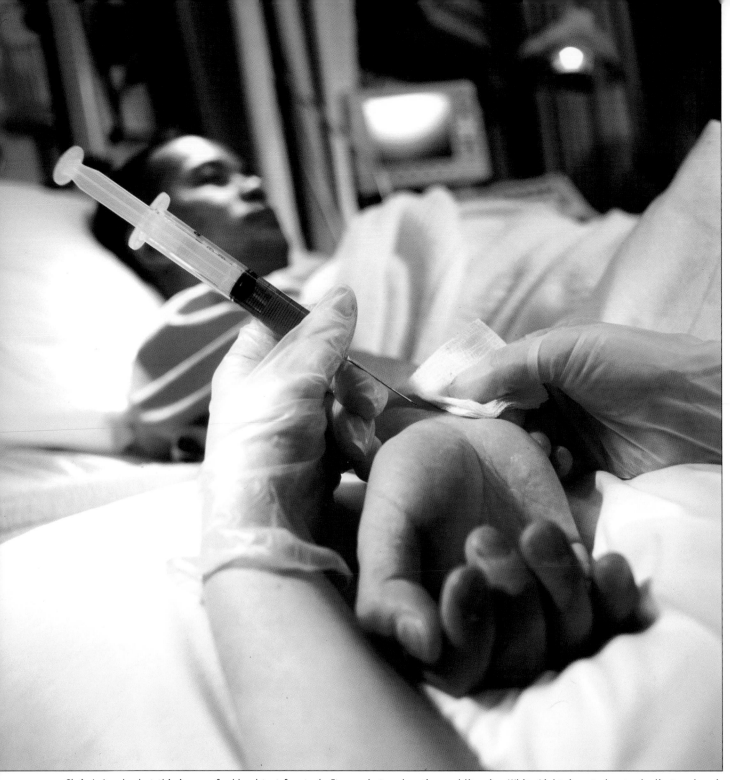

Chris LaLonde shot this image of a blood test for stock. It was shot on location and lit using White Lightning strobes to duplicate a hospital room's stark lighting. The colors were desaturated in Photoshop to give the image a sterile, cold feeling.

"feathered" by aiming the core of light away from the subject and using just the edge of the beam of light.

Flats. Flats are large, white opaque reflectors that are portable (usually on rollers or castors) and used as reflectors. Once wheeled into position, lights are bounced into them like a temporary wall.

Gobos. Gobos (or black flags, as they're sometimes called) are panels that are used as light blockers. In the studio, they are used to shield a part of the subject from light. In the field, they are often used to block overhead light when no natural obstruction exists. This reduces the overhead nature of the lighting, minimizing the

darkness under the eyes. In effect, the overhead gobo lowers the angle of the main light source so that it is more of a sidelight. Gobos are also used to create a lighting ratio when the source of the main light is very large, with little or no light falloff on the shadow side of the subject. In this case, the gobo essentially reflects black onto the shadow side of the subject.

Grid Spots. Grid spots are honeycomb metal grids that snap onto the perimeter of the light housing. They come usually in 10-degree and 45-degree versions, the 10-degree grid being the narrower beam of light. Each cell in the honeycomb prevents the light from spreading out, so grid spots produce a narrow core of light with a diffused edge that falls off quickly. Because the light is collimated, there is very little spill with a grid spot. As a result, grid spots provide a great amount of control and allow you to place light in a specific and relatively small area. Grids are ideal for portraiture where a dramatic

Anthony Cava created this striking image with a parabolic light source off to the right to light her body. He then used a light with a grid spot (to narrow the beam of light) to illuminate her face. The parabolic reflector and grid light produce a much harder light than softboxes or window light, as evidenced by the hard shadows on the background and the distinct shadow under her nose that mirrors the lighting pattern. Direct light not only produces distinct shadows, but it creates levels of highlights on contoured surfaces.

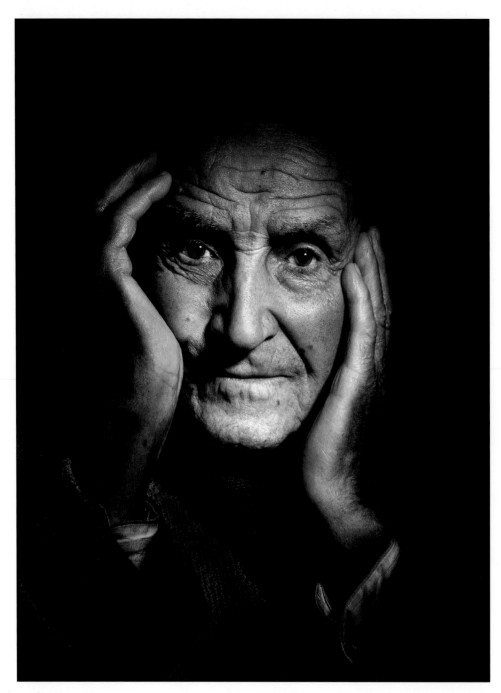

LEFT—Anthony Cava captured this remarkable portrait of an old friend who lived near his Ottawa studio. Anthony used a single strobe with a 10-degree grid spot at a steep angle so that the light was almost overhead. The light skimmed across the old man's skin to reveal texture and specular brilliance in the highlights. The grid spot narrowed the beam of light drastically so that the light became a narrow but intense shaft of light with a feathered edge. **FACING PAGE**—Reflective objects like rings are extremely difficult to photograph well. The rings were photographed separately on white Plexiglas using a Kodak SLR/n digital camera and a custom-made close-up lens at f/16. Nikon SB80s and a series of small white cards were used to photograph the rings. The lilies and background were photographed with a 20x36-inch softbox containing a 1200 White Lightning strobe. The images of the rings and lily stalks were combined later in Photoshop.

one-light effect is desired. Because the light naturally feathers at its edge, it provides a beautiful transition from highlight to shadow. If the grid spot is the only frontal light used in a studio setting, the light will fall off to black, for a very dramatic effect.

Light Tents. Light tents are nothing more than translucent tents that surround a subject. Lights are placed outside the tent and a small slit or hole is left in the tent surface so that the camera lens can be positioned. The idea is to wash the subject in diffused light—light that comes from every direction as a result of the scatter caused by the translucent tent material. Light tents are ideal for photographing small reflective objects like jewelry, which have dozens of curved, reflective surfaces. When placed in a light tent, the only thing reflected by these objects will be the tent surface, which reads as diffuse white. For gradations, small strips of opaque tape are often applied to the inside of the tent. Depending on the geometry and tone of the object, these will reflect black or gray into the object.

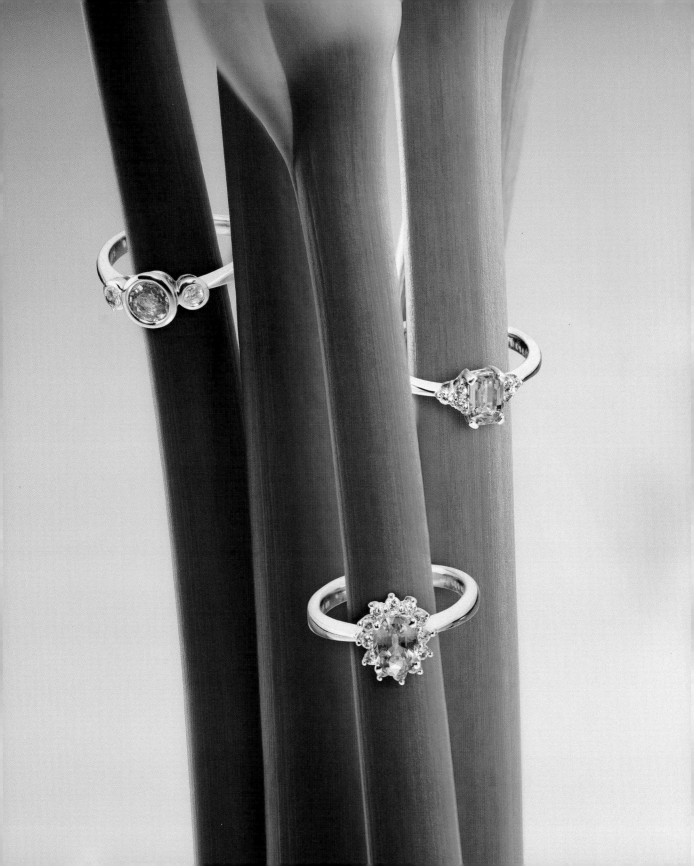

Believe it or not, this beautiful food shoot by Chris LaLonde was made by available light, diffused by an oversized scrim in an 8-foot window in Chris's studio. Directly opposite the window was a large 2x4-foot white Fome-Cor reflector, and throughout the set are 10 small makeup mirrors on stands. These were used to redirect direct light back onto the food and place setting, creating effects ranging from soft fill-in light to bright specular highlights that create bold accents on the crawfish. The photo was made with a Nikon D1X and 50mm f/1.4 lens at ⅛ second at f/4 in RAW mode at ISO 125.

Mirrors. Mirrors are used to bounce light into shadow areas or to provide a reflected main light. Because mirrors reflect a high percentage of the light that strikes them, they can be used outdoors to channel backlight into a main light. On a tabletop setup, small mirrors the size of matchbooks are sometimes used to kick light into a hard-to-light shadow areas. This technique is especially useful in lighting food, where deep shadows are unacceptable and strong specular highlights project a freshness and "just cooked" feeling to the food.

Reflectors. Reflectors are large white, silver, or gold surfaces that are used to bounce light into the shadow areas of a subject. A wide variety or reflectors are available commercially, including the kind that are collapsible and store in a small pouch. The silver- and gold-foil surfaces provide more light than matte white or translucent surfaces—and the gold reflectors are ideal for shade, where a warm-tone fill is desirable. Black reflectors are also available for subtractive lighting effects.

When using a reflector, it should be placed slightly in front of the subject's face, not beside it where it may resemble a secondary light source coming from the opposite direction of the main light. Properly placed, the reflector picks up some of the main light and wraps it around onto the shadow side of the face, opening up detail even in even the deepest shadows.

Portable LiteDiscs from Photoflex are flexible reflectors that fold up into a compact shape for transport. They come in a variety of surfaces and sizes—some are even reversible.

Reflectors, Wide-Angle. Strobe heads accept different size reflectors, which mount to the perimeter of the flash-head housing. The smallest of these is usually the five-inch wide-angle standard reflector, which is a very shallow pan reflector. With this reflector attached, light is reflected out in a wide pattern. This reflector is often used to focus light onto the full surface of an umbrella. Without a reflector (i.e., barebulb) the light would scatter everywhere, making it less efficient. Wide-angle reflectors also make the flash head suitable for bouncing off of ceilings and walls and for shooting into flats or scrims. Bounced light is very soft and usable. The light quality can be controlled by changing the distance from the flash head to the reflector, wall, or ceiling. Another good thing about wide-angle reflectors is that they protect the flash tube and modeling light from damage, and they make the light more compact for traveling.

Reflectors, Narrow-Angle. Twelve-inch and wider reflectors are useful for situations where specular (sharp-edged) light is needed in a narrow angle. These reflectors, while having a larger circumference than the wide-angle reflectors, are much deeper and thus create a more defined, narrower beam of light. Some pan reflectors are polished; some use a brushed matte surface, which has the effect of diffusing the beam of light. Some have facets that gather and focus the light. Photographers rarely use undiffused pan reflectors any more, favoring various diffusion methods, but for beautiful specular light and a highly functional feathered edge to the light, nothing beats the polished pan reflectors, which are often called parabolics because of the shape of the pan.

Many photographers prefer using this reflector when the strobe is to be bounced off of reflective surfaces like walls or ceilings. The narrower spread of light is controllable and efficient, with less light loss.

Reflectors, Parabolic. Parabolics are polished silver metal reflectors into which the lamp or strobe heads are placed for a sharp light with well defined shadows and lots of contrast. Parabolics create a light pattern that is brighter in the center with light gradually falling off in intensity toward the edges. The soft edge of the circular light pattern, called the penumbra, is the area of primary concern to the portrait photographer. The center of the light pattern, the umbra, is hot and unforgiving

and produces highlights without detail on the face. Feathering the light (adjusting the light so as to use the penumbra) will help achieve even illumination across the facial plane with soft specular highlights.

Scrims. Scrims are translucent diffusers. Light is directed through the material of the scrim to diffuse the light. In the movie business, huge scrims are suspended like sails on adjustable flats or frames and positioned between the sun (or a bank of lights) and the actors, diffusing the light over the entire stage area. A scrim works the same way a diffuser in a softbox works, scattering the light that shines through it. Monte Zucker has perfected a system of using large scrims—3x6 feet and larger. With the sun as a backlight, he has two assistants hold the translucent light panel above and behind the subject so that the backlighting is diffused. In front of the subject(s) he uses a reflector close to the subject to bounce the diffused backlight onto the subject(s). The shadowless lighting effect is very much like that achieved with an oversized softbox.

Scrims can also be used in window frames for softening sunlight that enters the windows. The scrim can be

A CLASSIC LIGHTING STYLE

In the old days, the light intensity needed to capture an image on very slow film required all portrait be lit with parabolics and continuous-light sources. While today's strobe technology is great, there *is* an advantage to learning lighting with parabolics. With these harder sources, you have to see and control light more efficiently than with diffused lights, which are much more forgiving.

tucked inside the window frame and made invisible from the camera position.

Snoots. These are attachments that snap to the light housing and resemble a top hat. Snoots narrow the beam of light into a very thin core. They are ideal for small edge lights used from behind the subject.

Softboxes. A softbox is like a tent housing for one or more undiffused strobe heads. Often, fiberglass poles provide the rigid support of the softbox housing. The frontal surface is translucent nylon, usually double

FACING PAGE—Cherie Steinberg Coté created this beautiful fashion image that shows off the necklace with amazing clarity. The lighting in this image is superb and much different than portrait light, where facial details are of paramount importance. This lighting is diffused and directional but geared specifically to show off the gown and necklace. Cherie shot the image with a Nikon D70 in RAW mode with a 16mm lens. **RIGHT**—Cherie Steinberg Coté also created this portrait by incorporating a busy downtown L.A street scene, a gorgeous bride in a black veil in full makeup, and diffused flash at the same output as the daylight exposure. The result is an edgy portrait where the background and portrait are both perfectly exposed.

LEFT—This is a self portrait that Chris LaLonde created for publicity use. He lit the portrait with a single softbox overhead to create a bold but soft lighting pattern. He feathered the light away from his face to use its more dynamic edge. (*Note:* you can see the position of the softbox by examining the catchlights in his eyes.) In Photoshop, he softened everything behind the mask of his face and darkened the area as well. Chris, who shoots with Nikon DSLRs, often uses a laptop for proofing and fine-tuning the image, as well as for camera control. **BELOW**—This striking image by Cherie Steinberg Coté was made with a single tungsten spotlight, which produced a strong shadow that was used as part of the composition. The image was captured with a Nikon D100, using the camera's tungsten white-balance mode. Using a DSLR makes it much easier to produce color-balanced images—just match the white balance to your light source. With a film camera, you would need to change film or employ a color-correction filter.

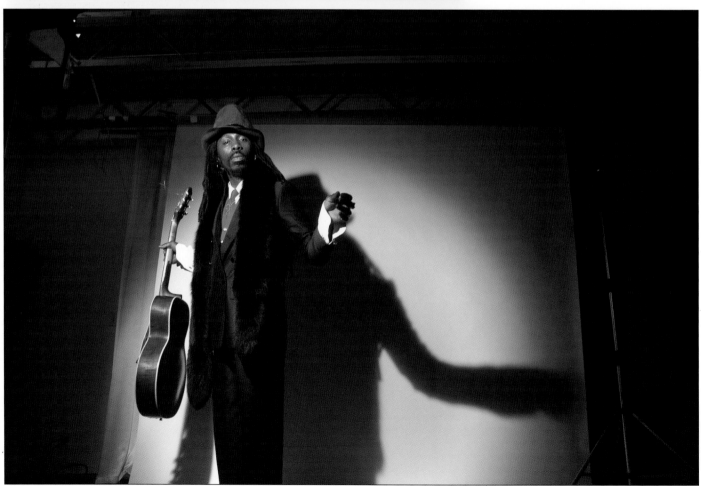

thickness. The sides are black on the outside and white on the inside to gather and diffuse more light. Softboxes come in many sizes and shapes. Although mostly square, there are a few round ones out there. The sizes range from 12 inches square all the way up to 5x7 feet. Softboxes are the ideal means of putting a lot of soft light in a controlled area. They provide much more precise control over the light than umbrellas, which lose much of their light intensity to scatter. Some softboxes accept multiple strobe heads for additional lighting power and intensity.

Spotlights. A spotlight is a hard-edged light source. Usually it is a small light with a Fresnel lens attached. The Fresnel is a glass filter that focuses the spotlight, making the beam of light stay condensed over a longer distance. Barn doors are usually affixed to spots so that they don't spray light all over the set.

Spots are often used to light a selective area of the scene, like a corner of the room or a portion of a seamless background. They are usually set to an output that is less than the main light or fill, although they may also be used as a main light at times.

Spots produce a distinct shadow edge, giving more shape to the subject's features than lower-contrast, diffused light sources. Although originally a hot light, various strobe manufacturers have introduced strobe versions of Fresnel spots.

Strip Lights. A strip light is a long, skinny softbox. These are used as background and hair lights in portraiture, as well as edge lights for contouring in tabletop photography. Sometimes they can be used as odd-shaped main lights, although their small size makes it tricky to use them for this purpose.

Umbrellas. Umbrellas, while not as popular as they once were, are still useful for spreading soft light over large areas. They produce a rounded catchlight in the eyes of portrait subjects and, when used close to the subject, provide an almost shadowless light that shows great roundness. Umbrellas are usually used with a short, wide-angle reflector on the flash head that enables you to better focus the entire beam of light. Umbrellas need to be focused to be optimized. All that means is sliding the umbrella back and forth until the light covers the entire umbrella surface without spill.

Photographic umbrellas are either white or silver. A silver-lined umbrella produces a more specular, direct light than does a matte white umbrella. When using lights of equal intensity, a silver-lined umbrella can be used as a main light because of its increased intensity and directness. It will also produce wonderful specular highlights in the overall highlight areas of the face. A matte-white umbrella can then be used as a fill or secondary light.

Umbrellas, Shoot-Through. Some photographers use a translucent umbrella in the reverse position, turning the light and umbrella around so that the light shines through the umbrella and onto the subject. This gives a softer, more directional light than when the light is turned away from the subject and aimed into the umbrella. Of course, with a silver-lined umbrella, you can't shine the light through it because the silvered material is almost fully opaque. There are many varieties of shoot-through umbrellas available commercially and they act very much like softboxes.

■ ON-CAMERA FLASH

Even at weddings, on-camera flash is used sparingly these days because of its flat, harsh light. As an alternative, many photographers use on-camera flash brackets, which position the flash over and away from the lens, minimizing red-eye and dropping the harsh shadows behind the subjects—a slightly more flattering light.

On-camera flash is, however, often used outdoors, especially with TTL-balanced flash exposure systems.

A combination of window light and bounce flash produced this striking portrait that accentuates the light-blue eyes of the beautiful bride. Photograph by Jeff Kolodny.

With such systems, you can adjust the flash output for various fill-in ratios, thus producing consistent exposures. In these situations, the on-camera flash is most frequently used to fill in the shadows caused by the daylight, or to match the ambient light output, providing direction to the light.

Bounce-Flash Devices. Many photographers use their on-camera flash in bounce flash mode. A problem, however, with bounce flash is that it produces an *overhead* soft light. With high ceilings, the problem is even worse—the light source, while soft, is almost *directly* overhead. There are a number of devices on the market that solve this problem. For example, the Lumiquest ProMax system allows 80 percent of the flash's illumi-nation to bounce off the ceiling while 20 percent is redirected forward as fill light. The system also includes interchangeable white, gold, and silver inserts, as well as a removable frosted diffusion screen. This same company also offers devices like the Pocket Bouncer, which enlarges and redirects light at a 90-degree angle from the flash to soften the quality of light and distribute it over a wider area. While no exposure compensation is necessary with TTL flash exposure systems, operating distances are somewhat reduced. With both systems, light loss is approximately $1\frac{1}{3}$ stops, however with the ProMax system, using the gold or silver inserts will lower the light loss to approximately $\frac{2}{3}$ stop.

■ HANDHELD VIDEO LIGHTS

Australian wedding and portrait photographer David Williams uses small handheld video lights to augment existing light at weddings or on location. He glues a Cokin Filter holder to the front of the light and places a medium blue filter (a 025 Cokin filter) in the holder. The filter brings the white balance back from tungsten to about 4500°K, which is still slightly warmer than daylight. It is the perfect warm fill light. If you want a warmer effect, or if you are shooting indoors with tungsten lights, you can simply remove the filter.

These lights sometimes have variable power settings. Used close to the subject (within 10 feet) they are fairly bright, but can be bounced or feathered to cut the intensity. David uses them when shooting wide open, so they are usually just providing fill or accent lighting.

The video light can also be used to provide what David calls, a "kiss of light." He holds the light above and to the side of the subject and feathers the light back and forth while looking through the viewfinder. The idea is to add just a little warmth and light to a backlit object, or a little dimension to something that is lit nondescriptly.

Sometimes, David uses an assistant to hold two lights, which cancel out the shadows of one another. He often combines these in a flash-bracket arrangement with a handle. His video light has a palm grip attached to the bottom to make it more maneuverable when he has the camera in the other hand.

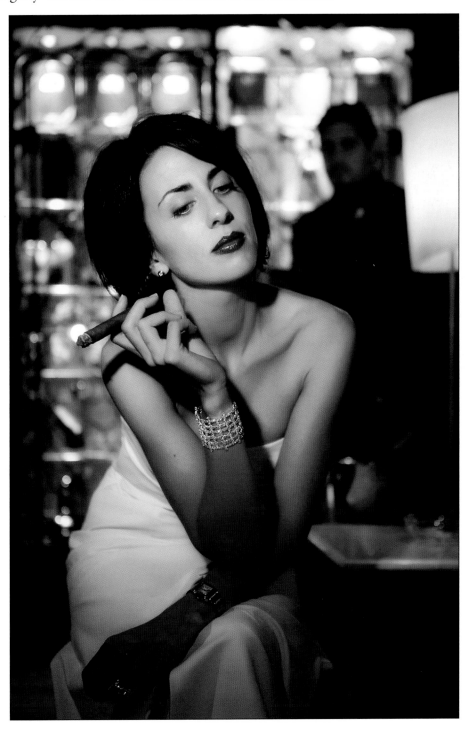

Yervant captured this beautiful cigar-smoking bride in a darkened pub by using a handheld video light, a Lowell I-Light, which can be feathered and held at any angle to create a strong lighting pattern. The I-Light is either a 50- or 100-watt handheld video light that is battery powered. These are ideal to use with digital capture because the camera can be set to the precise white balance of the video light and also because you instantly see the precise effect of the lighting.

4. GOOD DIGITAL WORKING TECHNIQUES

Working with digital files is very much different than working with film. For one thing, the exposure latitude, particularly when it comes to overexposure, is almost non-existent. Some photographers liken shooting digital, especially JPEGs, to shooting transparency film: it is unforgiving in terms of its exposure latitude. The up side of this seeming flaw in the process is that greater care taken in creating a proper exposure only makes you a better photographer. But for those used to ½ stops of over- and underexposure latitude, this is a different ballgame altogether.

Proper exposure is essential in that it determines the dynamic range of tones and the overall quality of the image—in fact, it is one of the key factors determining the quality of the final output from your digital file. Underexposed digital files tend to have an excessive amount of noise; overexposed files lack detail in the highlights.

According to Claude Jodoin, a wedding and event photographer and digital expert, "Your days of overexposing are over! You must either be right on with your exposures or, if you make an error, let it be only slightly underexposed, which is survivable. Otherwise you will be giving refunds to your clients. Overexposure of any kind is death with digital." Strong words to be sure, but with digital capture you must guarantee that the dynamic range of the processed image fits that of the materials you will use to exhibit the image (i.e., the printing paper and ink or photographic paper).

■ FILE SIZE

The file size of an image is the digital size of the image file, measured in kilobytes (K), megabytes (MB), or gigabytes (GB). File size is related to the number of pixels in the image. Images with more pixels will produce more detail at a given printed size, require more disk space to store, and be slower to edit and print. Image resolution thus becomes a compromise between

FACING PAGE—White on white on white—it's a challenge for any photographer, but especially for one who shoots JPEGs. David Beckstead's technique is very good. Here he balanced a warm-toned, late-afternoon skylight with all of the ship's white tones and the bride's dress. Perfect exposure guarantees a full range of detail throughout the highlights. Beckstead made the image with a Canon EOS 1D Mark II and Canon EF 16–35mm f/2.8L USM lens at $\frac{1}{250}$ second at f/2.8 at an ISO of 500.

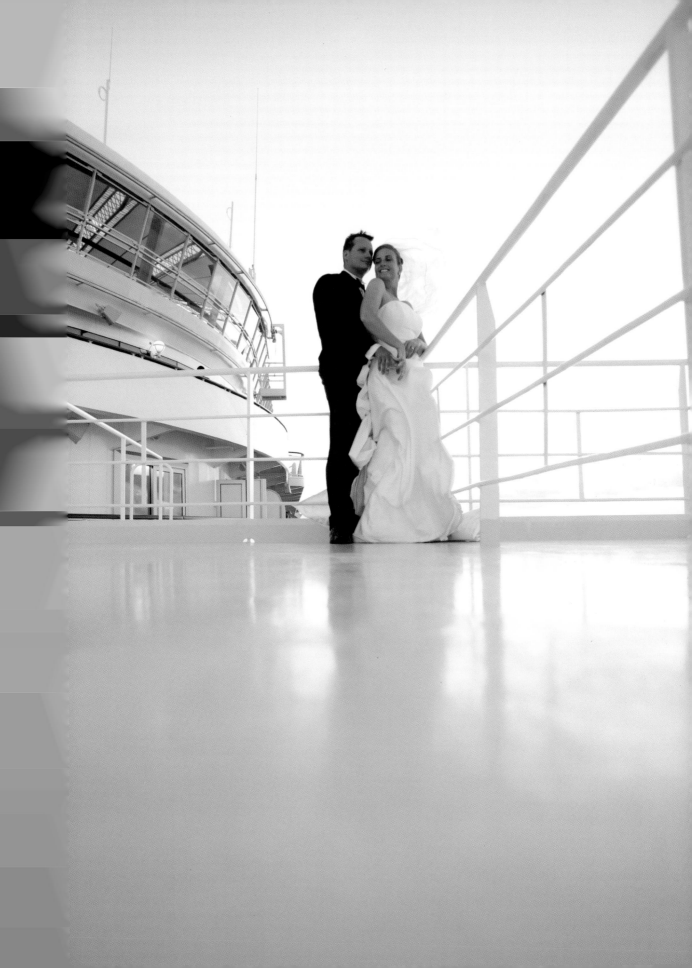

image quality (capturing all the data you need) and file size (being able to work with and transmit your image files efficiently).

Resolution. Resolution measures the number of pixels in an image. Resolution is sometimes identified by the width and height of the image, or as the total number of pixels in the image. For example, an image that is 2048 pixels wide and 1536 pixels high (2048x1536) contains 3,145,728 pixels or 3.1 megapixels (2048 x 1536 = 3,145,728). Therefore, you could call it a

2048x1536 or a 3.1 megapixel image. As the megapixels in the camera sensor increase so does the maximum print size. This means that a 5-megapixel camera is capable of producing a larger image than a 3-megapixel camera.

File Format. Another factor that affects file size is file format. Due to varying compression methods used by GIF, JPEG, and PNG file formats, file sizes can vary considerably for the same number of pixels. Similarly, color bit-depth and the number of layers and channels in an image affect the file size.

Changing Image Size and Resolution. There are many reasons why you may want to adjust the size of an image. Keep in mind, however, that these changes may involve corresponding changes in image quality.

Resampling. Resampling refers to changing the total number of pixels in an image. When you downsample (decrease the number of pixels), information is deleted from the image. When you upsample (increase the number of pixels), new pixels are added. Resampling can result in poorer image quality. For example, when you resample an image to larger pixel dimensions, the image will lose some detail and sharpness. Applying the Unsharp Mask filter to a resampled image can help restore the image's details.

Interpolation. Photoshop uses sophisticated methods to, as much as possible, preserve the quality and detail from the original image when you resample. In this process, the interpolation method determines how color values, based on the color values of existing pixels

BITMAP VS. VECTOR

When resizing an image, bitmap and vector data can produce different results. Bitmap data, which is made of rows of pixels, is resolution-dependent; therefore, changing the number of pixels in a bitmap image can cause a loss in image quality and sharpness. In contrast, vector data is comprised of mathematical formulas for its different shapes. This makes it resolution-independent, so you can resize it without losing its crisp edges.

Every good picture starts with a good exposure, as did this one by David Beckstead. David captured this image knowing that he would later, in Photoshop, use a nik ColorEfex filter to soften the shot and blend the highlights and shadows. David used his Canon EOS 1D Mark II and wide-angle lens to capture the scene at ISO 320. He shot the image as a high-quality JPEG.

For minor adjustment, you can boost image size in Photoshop by working in small increments. For example, if the image is 6x9 inches at 300dpi, and you want to make it 8x12 at 300dpi, go to Image>Image Size and check Constrain Proportions, Scale Styles, and Resample Image. In the Resample menu, select Bicubic Smoother. Tab to the width of the image and add a small increment—perhaps 6.5 inches. Repeat the process in small increments until the desired size is reached. The final step is to apply the Unsharp Mask. You will be amazed at the quality this method produces. Original photo (facing page) by Fernando Basurto.

in the image, are assigned to any new pixels Photoshop creates. The three interpolation methods most useful for resizing photos are as follows:

1. **Bicubic:** A slow but precise method resulting in the smoothest tonal gradations.
2. **Bicubic Smoother:** Produces smoother results when you're enlarging images.
3. **Bicubic Sharper:** The best setting for reducing the size of an image. This method maintains the detail in a resampled image. It may, however, over-sharpen some areas of an image. If this occurs, try using Bicubic.

These are set in the General Preferences dialog box, where you specify a default method to use when images are resampled with the Image Size or Transform commands. In the Image Size dialog box, you can also specify an interpolation method other than the default.

Step Interpolation. Fred Miranda (www.fredmiranda.com) is a photographer who produces plug-ins that make dealing with digital files a snap. His SI Pro 2, is a Photoshop plug-in that allows you to increase image size by percentage or to a set print size. It works by gradually increasing the image size in small increments (steps) and sharpening at optimum points within the process. The task runs like an action in Photoshop. You set the parameters and it works to complete the file, renaming it in the process so you don't accidentally destroy the original.

■ EXPOSURE AND METERING
Determining Your Camera's E.I.. Not all digital cameras are created equal. As with all things man-made, there are manufacturing and production tolerances that make complex devices dissimilar. It is important to know if your camera's metering system, on which you will rely heavily, is faster or slower than its rated ISO.

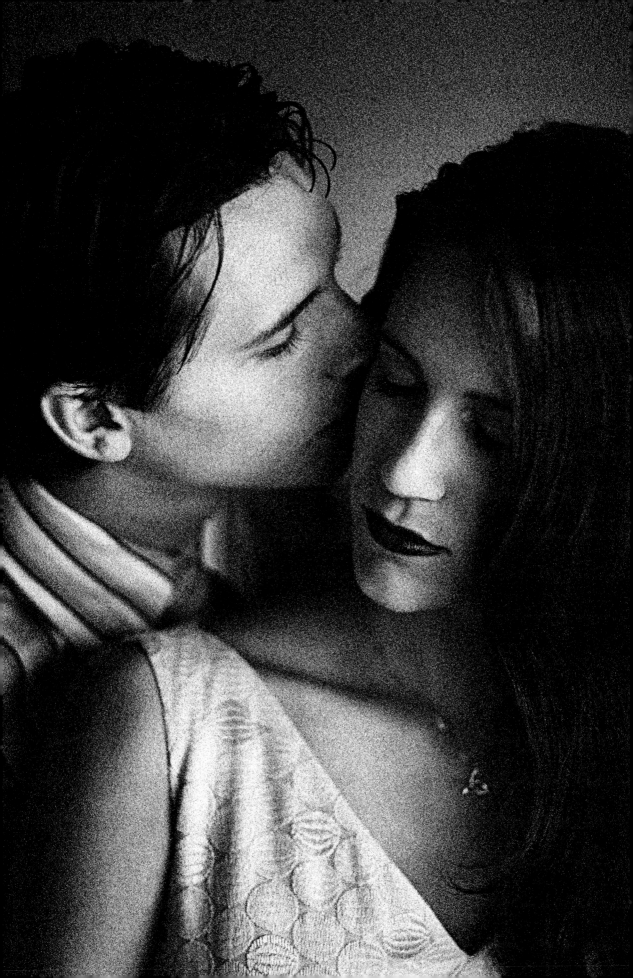

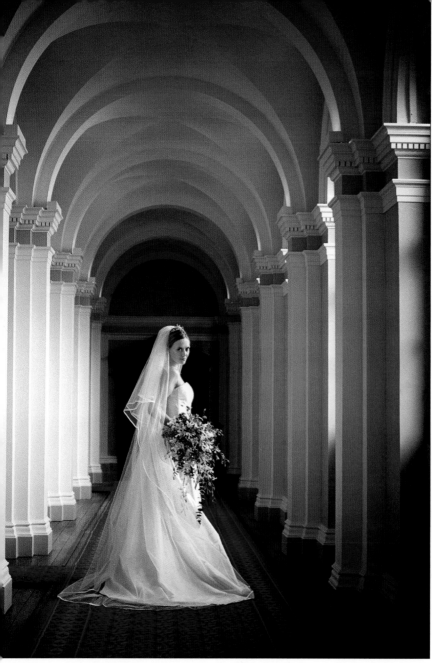

In this print made by David Worthingto[n] international competition, you can se[e] painstaking efforts needed to create a[per]fect print. The vast tonality in this i[mage] creates a visual feast for the viewer. [Note] the criss-cross tones of the arched ce[iling] and the long gradients of detailed [high]lights in the vertical columns. Wort[hing]ton's expertise comes in not only capt[uring] a perfect exposure and manipulating [the] print with mastery (note the subtle c[orner] vignettes), but also knowing the pe[rfect] time of day to work at a location.

slightly underexposed, so adjust [the] setting to E.I. 320 or E.I. 250 [and] make another frame and review [the] histogram. If the spike is to [the] right of center, the frame is over[ex]posed and you will have to red[uce] exposure by setting the ISO to [a] ½ stop higher; i.e., E.I. 500 or [E.I.] 620. Once the spike is proper[ly in] the middle of the histogram, [you] have a perfect exposure for this [par]ticular lighting.

So how do you apply w[hat] you've learned? If you repeat [the] test at different ISOs and under [dif]ferent lighting conditions, [you] should come up with a reliable [fac]tor. Or, you may find your met[er is]

Here's an adaptation of a simple test that technical [w]iz Don Emmerich came up with using an 18-percent [g]ray card. Simply fill the frame with the 18-percent gray [c]ard and meter the scene with the in-camera meter. [E]xpose an image exactly as the meter indicates and view [t]he histogram.

If the ISO is dead on, there will be a single spike [d]ead center in the histogram. If the spike is to the right [o]r left of center, adjust the camera's ISO by ⅓ or ½ stop [a]nd try again. If, for example, your initial test was made [w]ith an ISO of 400 and the spike on the histogram is [s]lightly to the left of center, it means the exposure is

perfectly accurate. If, however, you find that the m[eter] is consistently underexposing frames by ⅓ stop, you [can] add ⅓ stop of exposure compensation. If, on the o[ther] hand, the meter is consistently overexposing by ⅓ s[top,] for example, dial in –⅓ stop of exposure compensa[tion] or adjust your ISO accordingly.

Perform this same series of tests with your hand[held] incident meter to make sure all the meters in your a[rse]nal are precisely accurate.

Metering. The preferred type of meter is the ha[nd]held digital incident-light meter, which measures l[ight] in small units—tenths of a stop. This type of meter [can]

not measure the reflectance of the subjects, but rather it measures the amount of light falling on the scene. Simply stand where you want your subjects to be, point the meter's dome (hemisphere) directly at the camera lens, and take a reading. This type of meter yields extremely consistent results, because it is less likely to be influenced by highly reflective or light-absorbing surfaces, like white dresses or black tuxedos.

There is another school of thought on where to point an incident meter. Some photographers insist that one must point the meter at the light source and not at the lens. Sometimes there is no difference in the readings, but sometimes there is—up to ½ stop, which can make a difference in digital exposures. It is advisable to get into the habit of metering in both ways. Then make two test exposures at the different settings and view them on the LCD to see which is more accurate.

ANOTHER APPROACH

When using an incident meter, if you can't physically get to your subject position to take a reading, you can meter the light at your location—provided it is the same as the lighting at the subject position.

As noted above, it is advisable to run periodic checks on your meter, if you base the majority of your exposures on its data. If your incident meter is also a flashmeter, you should check it against a second meter to verify its accuracy. Like all mechanical instruments, meters can become temporarily out of whack and need periodic adjustment.

With advances in multi-pattern metering, in-camera metering has been vastly improved, however, one must

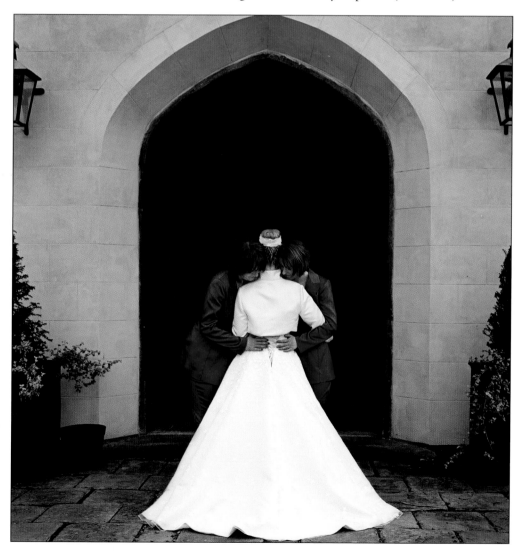

Digital files allow the photographer a clear path to his or her unique vision. In this incredible study of symmetry, David Worthington altered the dynamic range of the image so that the highlights of the dress and terracotta wall had detail, yet the darks of the massive door and planters were devoid of detail, becoming a canvas for these precisely composed image elements.

still recognize those situations when a predominance of light or dark tones will unduly influence the meter reading and subsequent exposure.

■ EVALUATING EXPOSURE

There are two ways of evaluating exposure of the captured image: by judging the histogram and by evaluating the image on the camera's LCD screen.

Histograms. By far, the most reliable way to judge exposure is using the histogram. This is a graph that indicates the number of pixels that exist for each brightness level. Histograms are scene-dependent. In other words, the number of pixels for each brightness level will directly relate to the subject and how it is illuminated and captured.

A low-key image, like this one Mercury Megaloudis made of a Mercedes decked out with ribbons for the wedding day, has its data points concentrated in the shadow area of the histogram (the left side of the graph). (*Note:* The screen captures to the right and on the facing page show the Histogram palette in Adobe Photoshop.)

The range of the histogram represents 0–255 from left to right, with 0 indicating "absolute" black and 255 indicating "absolute" white. In an image with a good range of tones, the histogram will fill the length of this graph (i.e., it will have detailed shadows and highlights and everything in between), but without going off at the ends. When data goes off the right end of the graph, the highlight portion, this means that the highlights are lacking image detail. When the data falls short of the right side and bunches up on the left side, you know the

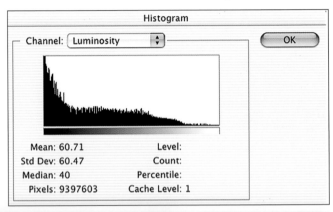

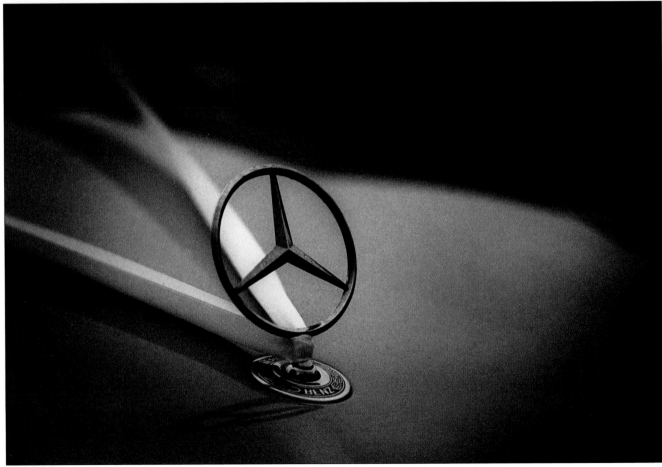

image is underexposed. In a properly exposed image, the histogram may show detail throughout (from 0–255) but it will trail off on either end of the graph. Detailed highlights will fall in the 235–245 range; detailed blacks will fall in the 15–30 range (in RGB).

The histogram also gives an overall view of the "key" of the image. A low-key image has its detail concentrated in the shadows (a high number of data points at the low end of the scale); a high-key image has detail concentrated in the highlights (a high number of data

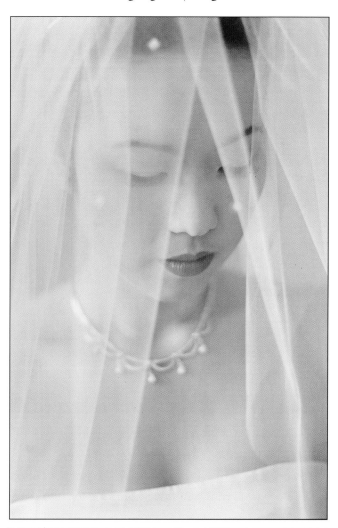

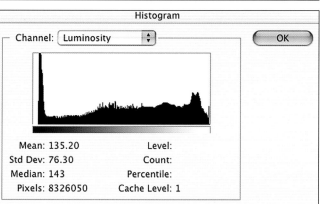

In a normally exposed image with an average range of highlights and shadows, the histogram will have the highest number of pixels in the midtones, as is seen here in this image by David Williams.

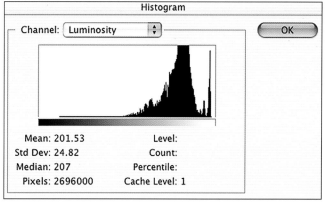

In a high-key image, such as this one by Ann Hamilton, the histogram has most of its image detail concentrated in the highlights (the right side of the histogram).

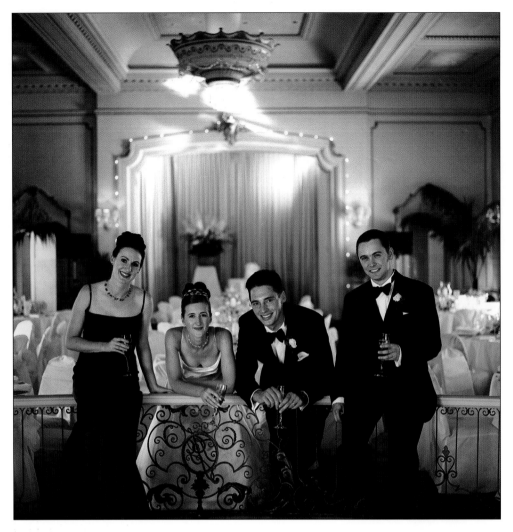

There are three different light sources in this scene: daylight streaming in through floor-to-ceiling windows behind the group, overhead tungsten light from room chandeliers, and low-wattage light from the camera position illuminating the subjects. The latter comes from a 10-watt handheld video light, which also dictated the white balance of the scene. This is a perfect situation for digital with its great flexibility for recording mixed lighting. Photograph by David Williams.

points at the high end of the scale). An average-key image has detail concentrated in the midtones.

Evaluating an LCD Image. With higher resolution LCDs, larger screens, and more functions in the playback mode of the camera, there's no reason you can't use the LCD most of the time for evaluating images. For example, most professional DSLRs let you zoom and scroll across an image to evaluate details. This will tell you if the image is sharp or not. Also, you can set certain playback presets to automatically indicate problems like "clipped" highlights. These are regions of the image in which no detail is present. I personally like this feature, because as the clipped highlights blink on the LCD preview, I can tell what areas were not properly exposed and how to remedy the situation. On Nikon's playback menu, you can scroll from histogram back to highlight-clipping mode in an instant. As you begin to use these features, they become second nature.

■ **CAMERA SETTINGS**

White Balance. White balance is the camera's ability to correct color when shooting under a variety of different lighting conditions, including daylight, strobe, tungsten, fluorescent, and mixed lighting. Choosing the right white-balance setting is very important if you are shooting highest-quality JPEG files. It is less important when shooting in RAW file mode, since these files contain more data than the compressed JPEG files and are easily remedied later in RAW processing.

DSLRs have a variety of white-balance presets, such as daylight, incandescent, and fluorescent. Some also allow the photographer to dial in specific color temperatures in Kelvin degrees. These are often related to a time of day. For example, a pre-sunrise shoot might call for a white-balance setting of 2000°K, while heavy overcast lighting might call for a white-balance setting of 8000°K.

Most DSLRs also have a provision for creating a custom white-balance setting, which is essential in mixed-light conditions, most indoor available-light situations, and with studio strobes. Many photographers like to take a custom white-balance reading of any scene where they are unsure of the lighting mix. By selecting a white area in the scene and neutralizing it with the custom white balance, you can be assured of a fairly accurate color rendition.

Other professional photographers swear by a device known as the Wallace ExpoDisc (www.expodisc.com), which attaches to the front of the lens like a filter. You

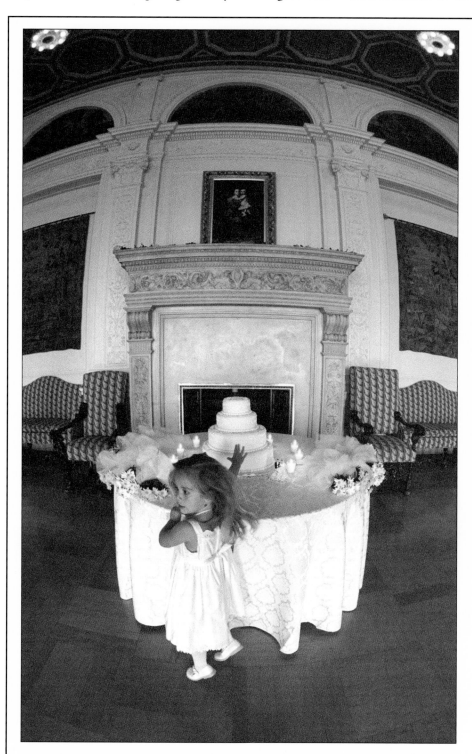

NOISE

Noise occurs when stray electronic information affects the sensor sites. It is made worse by heat and long exposures. Noise shows up more in dark areas, making night photography and long exposures problematic with digital capture. This is one of the areas where digital capture is quite different from film capture. New firmware on the latest DSLRs have long-exposure and noise-reducing modes, which, when selected, automatically invoke luminance smoothing (grayscale noise reduction) and chroma (color) noise reducing algorithms that minimize the overall noise recorded in these situations. These settings are quite effective, regardless of ISO.

Digital files taken in low light with high ISOs or for long exposure times create excessive noise, which can be minimized in RAW file processing or in camera presets. This image by Ann Hamilton was taken with a very wide-angle lens but the exposure was long enough to record the flickering candles and the overhead room lighting.

Mercury Megaloudis photographed a talkative cat named Jabber with a Canon EOS 10D and 100mm Macro lens wide open. He was concentrating on Jabber's brilliant blue eyes, opting to crop the image very tightly. The one eye was color enhanced in Photoshop then sharpened using Unsharp Mask to make it the focal point of the composition.

Chris Becker, "It's always easy to add contrast later, but more difficult to take away."

Color Space. Many DSLRs allow you to shoot in either Adobe RGB 1998 or sRGB color space. There is considerable confusion over which of these is the "right" choice. Adobe RGB 1998 is a wider-gamut color space than sRGB, so photographers reason that they should choose this in order to capture the maximum range of color. Professional digital imaging labs, however, use the sRGB color space for their digital printers. Therefore, professional photographers working in Adobe 1998 RGB will be somewhat disheartened when their files are reconfigured and output in the narrower color sRGB space.

Many photographers who work in JPEG format use the Adobe 1998 RGB color space all the time—right up to the point

take a white-balance reading with the disc in place and the lens pointed at your scene. It is highly accurate in most situations and can also be used to take exposure readings.

Contrast. Contrast should be adjusted to the lowest possible setting. According to wedding photographer

that files are sent to a printer or out to the lab for printing. The reasoning is that since the color gamut is wider with Adobe 1998 RGB, more control is afforded. Claude Jodoin is one such photographer. He likes to get the maximum amount of color information in the original file, edit the file in the same color space for maxi-

mum control of the image subtleties, then convert the image for output.

Is there ever a need for other color spaces? Yes. It depends on your particular workflow. For example, all the images you see in this book have been converted from their native sRGB or Adobe 1998 RGB color space to the CMYK color space for photomechanical printing. As a general preference, I prefer images from photographers be in the Adobe 1998 RGB color space as they seem to convert more naturally to CMYK.

Sharpening. In your camera's presets you will probably have a setting for image sharpening. You should choose "none" or "low sharpening." The reason for this is that sharpening can eliminate data in an image and cause minor color shifts. Sharpening is best done after the other post-processing effects are complete. Also, if shooting RAW files you will want to add sharpening in the RAW file-processing, where it is most effective.

Metadata. DSLRs give you the option of tagging your digital image files with data, which often includes the date and time, a caption, as well as the camera settings. In Photoshop, go to File>File Info to see a range of data, including caption and ID information. If you then go to EXIF data in the pull-down menu, you will see all of the data that the camera automatically tags with the file. Depending on camera model, various other information can be written to the EXIF file, which can be useful for either the client or lab. You can also add your copyright symbol (©) and notice either from within Photoshop or from your camera's metadata setup files. Adobe Photoshop supports the information standard developed by the Newspaper Association of America (NAA) and the International Press Telecommunications Council (IPTC) to identify transmitted text and images. This standard includes entries for captions, keywords, categories, credits, and origins from Photoshop.

GET IT RIGHT

Although it is true that an underexposed image is better than an overexposed one, an underexposed image will still never look as good as a properly exposed one. You can correct for underexposure in Photoshop, but it is time consuming to adjust exposure in this manner.

SYNC THEM UP

Wedding photographer Chris Becker offers this tip: if shooting with multiple camera bodies, be sure to sync the internal clocks of the cameras. This will make it much easier to sequentially organize your images after the event.

5. FILE FORMATS

Graphic file formats differ in the way they represent image data (i.e., as either pixels or as vectors), compression technique (how much data is compressed), and which Photoshop features they support. With the exception of the Large Document Format (PSB), Photoshop Raw, and TIFF, all file formats can only support documents with a file size of 2GB or less.

■ FILE COMPRESSION

Many file formats use compression to reduce the file size of bitmap images. Lossless formats compress the file without removing image detail or color information. Lossy formats remove detail. Here are some commonly used compression schemes:

LZW—Lossless compression; supported by TIFF, PDF, GIF, and PostScript language file formats.

JPEG—Lossy compression; supported by JPEG, TIFF, PDF, and PostScript language file formats. Recommended for continuous-tone images, such as photographs. When saving an image in Photoshop, you can specify the image quality by choose an option from the Quality menu (in the JPEG Options dialog box), entering a value between 0 and 12. For the best results, always choose the highest quality (10 to 12). JPEG files can be printed only on Level 2 (or later) PostScript printers and may not separate into individual plates for photomechanical reproduction.

ZIP—Lossless compression; supported by PDF and TIFF file formats. Like LZW, the ZIP compression strategy provides the greatest reduction in file size when used for images that contain large areas of a single color.

■ JPEG FORMAT

The JPEG (Joint Photographic Experts Group) format is commonly used to display photographs and other continuous-tone images in hypertext markup language (HTML) documents over the Internet and other online services. JPEG format supports CMYK, RGB, and Grayscale color modes, but does not support alpha channels. JPEG images retain all the color information in an RGB file but compress the file size by selectively discarding data. A JPEG image is automatically decom-

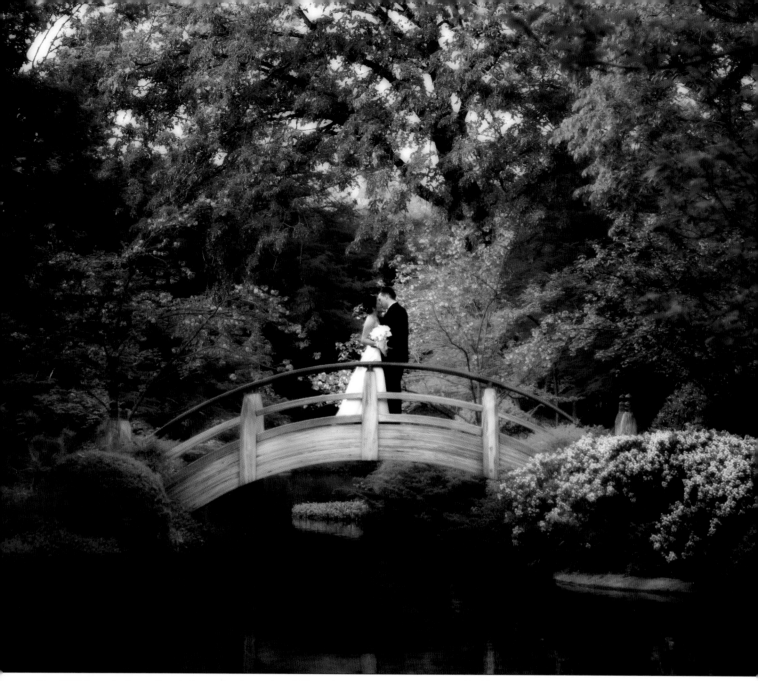

The JPEG format allows the photographer to work quickly and conserve storage space. This file, when closed, is 1.47MB as a JPEG. Once opened, it is a 20.60MB file, meaning that it was saved at less-than-highest quality as a JPEG. Once transported or sent to another party, files like these should be saved as lossless TIFF files to preserve the image data. This beautiful bridal formal was made by Kevin Jairaj.

pressed when opened. A higher level of compression results in lower image quality, and a lower level of compression results in better image quality.

■ JPEG 2000 FORMAT

JPEG 2000 provides greater flexibility than the standard JPEG format. Using JPEG 2000, you can produce images with better compression and quality for both Internet and print publishing. To save files in the JPEG 2000 format, an optional JPEG 2000 plug-in must be installed in Adobe Photoshop CS2. This can be found on the Photoshop CS2 installation CD in Goodies> Optional Plug-Ins>Photoshop Only> File Formats.

Unlike traditional JPEG files, which are lossy, the JPEG 2000 format supports optional lossless compression. The JPEG 2000 format also supports 16-bit color or grayscale files, 8-bit transparency, and it can retain alpha channels and spot channels. Grayscale, RGB, CMYK, and Lab are the only modes supported by the JPEG 2000 format.

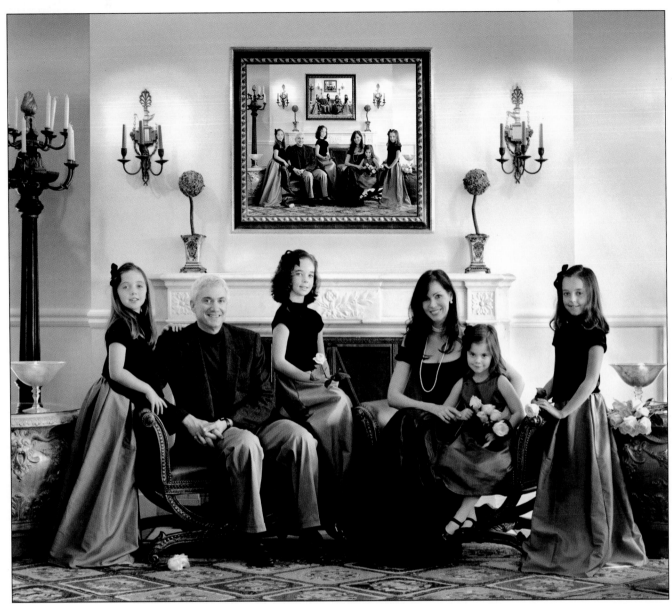

Kersti Malvre saves most of her files in PSD format. There are many reasons for this. You can preserve layers without having to flatten them so that the image can be altered later. Also, you can specify that the Photoshop data be saved in EXIF form within the metadata file for later reference. This beautiful portrait encapsulates an image of itself over the fireplace.

A very interesting feature of the JPEG 2000 format is that it supports using a Region of Interest (ROI) to minimize file size and preserve quality in critical areas of an image. By using an alpha channel, you can specify the region (ROI) where the most detail should be preserved, allowing greater compression and less detail in other regions.

■ GIF FORMAT

Graphics Interchange Format (GIF) is the file format commonly used to display indexed-color graphics and images in hypertext markup language (HTML) documents over the Internet. GIF is an LZW-compressed format designed to minimize file size and electronic transfer time. The GIF format preserves transparency in indexed-color images; however, it does not support alpha channels.

■ TIFF FORMAT

TIFF (Tagged Image File Format) files are the most widely used file format in digital photography. TIFF supports the following image modes: RGB, CMYK,

Grayscale, Lab, and Indexed color. TIFF files are lossless, meaning that they do not degrade in image quality when repeatedly opened and closed. TIFF files may be compressed when saved in Photoshop by using three different compression schemes: LZW, JPEG, or ZIP (see page 60).

TIFF files are used to exchange files between applications and computer platforms. TIFF is a flexible bitmap image format supported by virtually all painting, image-editing, and page-layout applications. Also, virtually all desktop scanners can produce TIFF files. TIFF documents can have a maximum file size of 4GB. Photoshop CS and later support large documents saved in TIFF format. However, most other applications (and older versions of Photoshop) do not support documents with file sizes greater than 2GB.

Photoshop can save layers in a TIFF file; however, if you open the file in another application, only the flattened image is visible. Photoshop can also save annotations, transparency, and multi-resolution pyramid data in TIFF format.

■ PHOTOSHOP EPS FORMAT

EPS (Encapsulated PostScript) files can contain both vector and bitmap graphics and are supported by virtually all graphics, illustration, and page-layout programs. EPS files are used to transfer PostScript-language artwork between applications. When you open an EPS file containing vector graphics, Photoshop rasterizes it, converting the vector graphics to pixels. The EPS format supports Lab, CMYK, RGB, Indexed Color, Duotone, Grayscale, and Bitmap color modes, but not alpha channels. EPS does, however, support clipping paths. To print EPS files, you must use a PostScript printer.

DCS. The DCS (Desktop Color Separations) format, a version of the standard EPS format, lets you save color separations of CMYK images. You can use the DCS 2.0 format to export images containing spot channels.

■ PSD FORMAT

PSD (Photoshop Document) is the default file format and the only format that supports most Photoshop features (other than the Large Document Format [PSB]). Due to the tight integration between Adobe products, other Adobe applications can directly import PSD files and preserve many Photoshop features.

When saving a PSD file for use in a previous version of Photoshop, you can set a preference to maximize file compatibility. Normally, you should choose Always from the Maximize PSD File Compatibility menu. This

In this image by Kersti Malvre, the Edit History is preserved in metadata form so that it can be referred to in precise detail at a later date.

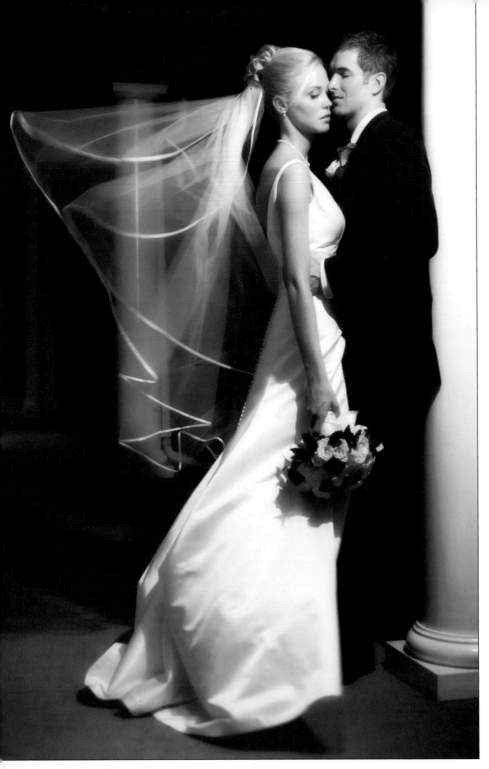

Kevin Jairaj created this beautiful portrait of a bride and groom for print competition. Kevin often shoots in the RAW format so he can adjust the skin tones and lighting subtleties after the capture. In this image, he used a single flash to light the couple and had an assistant "drop" the veil an instant before exposure so it would look like it was suspended in mid air.

Photoshop CS introduced nested layers, Hard Mix blending mode, Photo Filter adjustment layers, 56 channel limit, text on a path, support for files greater than 2GB, support for files greater than 30,000 pixels in any dimension, non-square pixels support, 16-bit layers, 16-bit patterns, and 16-bit Brushes.

Photoshop 7.0 introduced the Linear Burn, Linear Dodge, Vivid Light, Linear Light, and Pin Light blending modes, as well as the Layer Mask Hides Effect and Vector Mask Hides Effect advanced blending options.

Photoshop 6.0 introduced layer sets, layer color-coding, layer clipping paths, fill layers, layer styles, editable type, advanced type formatting, and new layer effects.

Photoshop 5.0 introduced layer effects (effects added in later versions of Photoshop are not supported, however), color samplers, spot channels, and embedded ICC profiles.

Photoshop 4.0 introduced adjustment layers and guides.

saves a composite (flattened) image along with the layers of the document. If file size is an issue or if you're *only* opening your files in Photoshop, turning off Maximize PSD File Compatibility will reduce the file sizes significantly.

If you edit or save your PSD image using an earlier version of Photoshop, any unsupported features will be discarded. Keep in mind the following features when working with earlier versions of Photoshop:

■ PHOTOSHOP RAW FORMAT

The Photoshop RAW format is a flexible file format for transferring images between applications and computer platforms. This format supports CMYK, RGB, and

grayscale images with alpha channels, as well as multi-channel and Lab images without alpha channels. Documents saved in the Photoshop RAW format can be any pixel or file size, but cannot contain layers. Images in the Photoshop RAW format consist of a stream of bytes describing the color information. Each pixel is described in binary format, with 0 representing black and 255 representing white (for images with 16-bit channels, the white value is 65535). Photoshop designates the number of channels needed to describe the image, plus any additional channels in the image. You can save the image in an interleaved or noninterleaved format. If you choose interleaved, the color values (red, green, and blue, for example) are stored sequentially. Your choice depends on requirements of the application that will open the file. (*Note:* Photoshop RAW is not the same file format as a RAW image file from a digital camera. A digital camera's RAW image file is a camera-specific proprietary format that provides the photographer with a digital negative—an image free of any filtering, white balance adjustments, or other in-camera processing.)

■ RAW FORMAT

RAW is a general term for a variety of proprietary file formats such as Nikon's .NEF, Canon's .CRW and .CR2, and Olympus' .ORF. While there are many different encoding strategies, in each case the file records the raw, unprocessed image-sensor data. RAW files consist of the image pixels themselves and the image metadata, which contains a variety of information about how the image was recorded.

How JPEG Differs from RAW. When you shoot JPEG, a built-in RAW converter in the camera carries out all of the same tasks as described above to turn the RAW capture into a color image, then compresses it using JPEG compression. Some camera systems allow you to set parameters for this JPEG conversion—usually, a choice of sRGB or Adobe RGB 1998 color space, a sharpness setting, and a curve or contrast setting.

This is an image file that was captured with a Nikon D70s in both JPEG and NEF (Nikon RAW) file formats simultaneously. In Adobe Camera RAW, the file was tweaked in the areas of white balance, exposure, and sharpness. Saved as a TIFF, it was then opened in Photoshop CS2. It was selectively diffused, lightly vignetted, and some minor burning and dodging and overall color-balance corrections were performed. Photograph by Bill Hurter.

JPEG. JPEGs offer fairly limited editing ability, since the mode applies heavy compression to the color data. In the typical conversion process, the JPEG compression will discard roughly a stop of usable dynamic range, and you have very little control over what information gets discarded.

So why do many photographers still choose to shoot JPEGs? First, shooting in JPEG mode creates smaller files, so you can save more images per CF card or storage device. Second, compared to shooting RAW files, JPEGs do not take nearly as long to write to memory. Both factors allow you to work much faster—a clear advantage in some situations. If you shoot JPEGs, selecting the JPEG Fine mode (sometimes called JPEG Highest Quality) will apply the least compression and, therefore, produce the best possible files.

JPEG is a "lossy" format, meaning that images are subject to degradation by repeated opening and closing of the file. Therefore, most photographers who shoot in JPEG mode save the file as a JPEG copy each time they work on it or save it to the TIFF format. TIFF is a "lossless" format, meaning that images can be saved again and again without further degradation.

RAW. When you shoot in RAW mode, you get unparalleled control over the interpretation of the image. The only in-camera settings that have an effect on the captured pixels are ISO speed, shutter speed, and aperture setting. Everything else is under your control when you convert the RAW file—you can reinterpret the white balance, the colorimetric rendering, the tonal response, and the detail rendition (sharpening and noise reduction) with complete flexibility. Within limits (which vary from one RAW converter to another), you can even reinterpret the exposure compensation.

While RAW files offer the benefit of retaining the highest amount of image data from the original capture, they also take longer to write to the storage media and drastically reduce the number of files you can capture on a single CF card or microdrive because of their increased file size. Although the cost of media is coming down, the time it takes to record the information is not necessarily getting much faster. If the kind of shooting you do requires fast burst rates and lots of image files, such as the wedding photographer or photojournalist would experience, then RAW capture may not be your best choice.

RAW File Converters. Because they include some additional metadata, RAW format files must be converted by a RAW image converter before they can be used. These converters process the white balance, colorimetric data (the assigning of red, green, and blue to each pixel), Gamma correction, noise reduction, antialiasing (to avoid color artifacts), and sharpening. However, different converters use different algorithms—some

DNG FORMAT

To resolve the disparity between RAW file formats, Adobe Systems introduced an open RAW file format, appropriately named the Digital Negative (DNG) format. Adobe is pushing digital camera manufacturers and imaging software developers to adopt the new DNG format. Unlike the numerous proprietary RAW formats out there, the DNG format was designed with enough flexibility built in to incorporate all the image data and metadata that any digital camera might generate. Proprietary RAW format images that are pulled into Photoshop can be saved to the new DNG file format with all the RAW characteristics being retained. DNG Save options include the ability to embed the original RAW file in the DNG file, to convert the image data to an interpolated format, and to vary the compression ratio of the accompanying JPEG preview image.

JPEG VS. RAW

In some ways, shooting JPEGs is like shooting transparency film, while shooting RAW is more like shooting color-negative film. With JPEG, as with transparency film, you need to get everything right in the camera because there's very little you can do to change it later. Shooting RAW mode provides considerable latitude in determining the tonal rendition and also offers much greater freedom in interpreting the color balance and saturation.

Apple's Aperture is an all-in-one post-production tool that provides everything photographers need for RAW file processing. Aperture offers an advanced and incredibly fast RAW workflow that makes working with a camera's RAW images as easy as working with JPEGs. Built from the ground up for pros, Aperture features powerful compare and select tools, nondestructive image processing, color managed printing, and custom web and book publishing. RAW images are maintained natively throughout Aperture without any intermediate conversion process, and can be retouched with exceptional results using a suite of adjustment tools designed especially for photographers.

process the tones with less contrast in order to provide editing maneuverability, others will increase the contrast of the file to achieve a more film-like rendition, for example. As a result, the same image may look different when processed by different RAW converter engines.

Only a few years ago RAW file processing software was limited to the camera manufacturer's software, which was often slow and tedious to use. Over time, the software and process has improved drastically and with the introduction of independent software like Adobe Camera RAW and Phase One's Capture One DSLR, RAW file processing is not nearly as daunting.

The first step is to access the files and save them for editing, storage, and output. You can access your images using the software supplied with your camera or photo-editing software that recognizes the RAW file type. Usually, image-browsing software is used to ini-

tially access the images. Your camera manufacturer may supply this software or it may be third-party software.

After displaying and verifying that all of the files exist on the card, save a version of all of your source files prior to making any modifications or adjustments. If you shoot in RAW mode, backup the RAW files as RAW files, as these are your originals. Most people use CD-ROMs for this purpose because the medium is inexpensive and writes quickly from most computers. You can also save your source files to an auxiliary hard drive.

Once backups are made you can process the RAW files after certain general parameters are set. You will need to establish things like your default editing program (i.e., Photoshop) and destination folder, file names, numbering sequence, and so forth.

Files can be processed individually or batch processed to apply certain characteristics (white balance,

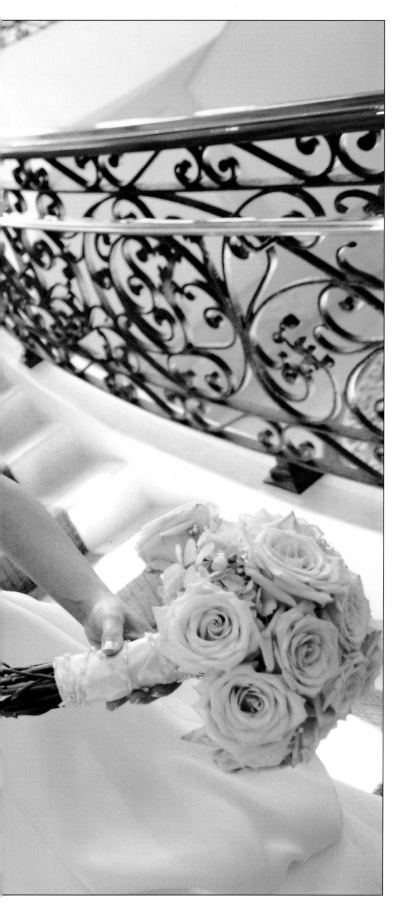

brightness, tagged color space, and more) to the entire group of images. Remember that your original capture data is retained in the source image file. Processing the images creates new, completely separate files. You will also have an opportunity to save the file in a variety of file formats, whichever is most convenient to your image-editing workflow.

Adobe Camera RAW. Adobe Camera RAW, Adobe's RAW file converter, is a sophisticated application within Photoshop that lets you far exceed the capabilities of what you can do to a JPEG file in the camera. For instance, by changing the color space from Adobe RGB 1998, a wide gamut color space, to ProPhoto RGB, an even wider gamut color space, it allows you to interpolate the color data in the RAW file upward. In the example shown on page70, the native file size is roughly 2000x3000 pixels. By converting the file to Pro-Photo RGB, the file can be easily enlarged to roughly 4000x6000 pixels, the equivalent of a 72MB file when it's opened in Photoshop—with almost no loss in quality. This is because the Pro-Photo RGB color space expands the native color data in the RAW file, making upward interpolation not only possible, but practical.

Using the Advanced Settings in Adobe Camera RAW, you can adjust many of the image parameters with much more power and discrimination than you can in the camera. For instance, under the Detail menu, you can adjust image sharpness, luminance smoothing, and color noise reduction (luminance smoothing reduces grayscale noise, while color noise reduction reduces chroma noise). In the Adjust menu you can control white bal-

Wedding photographer Becker downloads his images to a laptop in the field. Once the cards are downloaded, he transfers the downloads folder to an iPod (or any portable external FireWire hard drive) for safekeeping. He shoots more RAW files now than ever before. This beautiful backlit image was recorded with soft contrast, auto white balance, low saturation and soft sharpness. This allows finer interpolation in the RAW file processing of the image.

Shadow tint, hue, and saturation were adjusted. Also vignetting was adjusted in the Lens menu (not shown).

White balance, overall exposure, shadow exposure, brightness, contrast and saturation were then adjusted.

Sharpness, luminance smoothing and color noise reduction were then adjusted.

In the image shown here, the file was processed in Adobe Camera RAW. The color space was changed from Adobe RGB 1998 to ProPhoto RGB to increase the amount of color data to be processed.

The number of pixels was quadrupled—from the chip's native resolution of 2000x3000 pixels up to roughly 4000x6000 pixels.

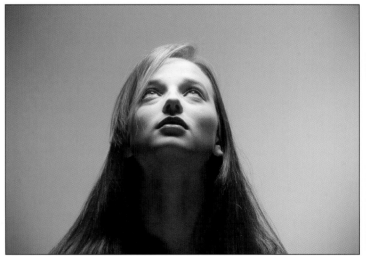

The final, processed 72MB file. RAW file image courtesy of Adobe.

ance, exposure, shadow density, brightness, contrast, and color saturation. The Lens menu lets you adjust lens parameters that affect digital cameras, such as chromatic aberration and vignetting. These controls exist to allow you to make up for certain optical deficiencies in lenses, but can also be used for creative effects, as well—especially the vignetting control, which either adds or subtracts image density in the corners of the image. In the Calibrate menu, you can adjust the hue and saturation of each channel (RGB), as well as shadow tint. (Shadow tint is particularly useful, as it provides the basis for color correction of images with people in them. In traditional color printing, color correction is done to neutralize the tint in the shadows of the face and body, so they are neutral gray. With shadow tint control, you isolate the shadows from the rest of the image so that you can neutralize the shadows, while leaving a warm tone, for example, in the facial highlights.)

In Photoshop CS2, Adobe Camera RAW combines with the modified file browser, called Bridge, to allow you to group a number of like files and correct them all the same way at the same time. This capability is a modified or selective batch processing that is much more useful than former means of batch processing. Plus you can continue working while the files process.

■ REFORMAT YOUR CARDS

After you backup your source files, it's a good idea to erase all of the images from your CF cards and then reformat them. It isn't enough to simply delete the images, because extraneous data may remain on the card causing data interference. After reformatting, you're ready to use the CF card again.

Never format your cards prior to backing up your files to at least two sources. Some photographers shoot an entire job on a series of cards and take them back to the studio prior to performing any backup. Others refuse to fill an entire card at any time; instead opting to download, back up, and reformat cards directly during a shoot. This is a question of preference and security. Many photographers who shoot with a team of shooters train their assistants to perform these operations to guarantee the images are safe and in hand before anyone leaves the wedding.

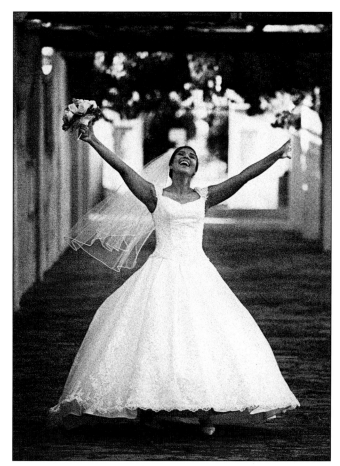

Fernando Basurto captured this marvelous image at a wedding using RAW file presets that increased brightness, contrast, and sharpness and reduced image noise. The image was made with a Canon EOS 1D Mark II and Canon EF 70–200mm f/2.8L IS USM lens at $\frac{1}{250}$ second at f/2.8 at ISO 400. Fernando capitalizes on the flexibility of RAW, but sets certain presets in order to accommodate his visual tastes and to speed up his workflow. Grain was added in Photoshop.

Bridge is a sophisticated application that is a part of Adobe CS2. It allows you to work across applications and perform batch-processing operations.

Tim Schooler always shoots in RAW mode, then converts the files in Phase One's Capture One. One of Schooler's settings in Capture One is for high-contrast skin tones and a 7-percent increase in color saturation. This gives his finished images a little more color, an effect he says seniors like a lot. Capture One has four options to emulate the look of film: Linear Response, Film Standard, Film Extra Shadows, or Film High Contrast. Tim used to use the Film Standard setting but found he was tweaking Curves too often. Now he uses Film High Contrast and he finds it's a lot closer to Portra VC, which was his preferred film before his studio went digital. "My goal is to shoot everything as a finished image, in fact that's how I proof. Nothing is edited or retouched before the client sees it. We retouch only what they ask for."

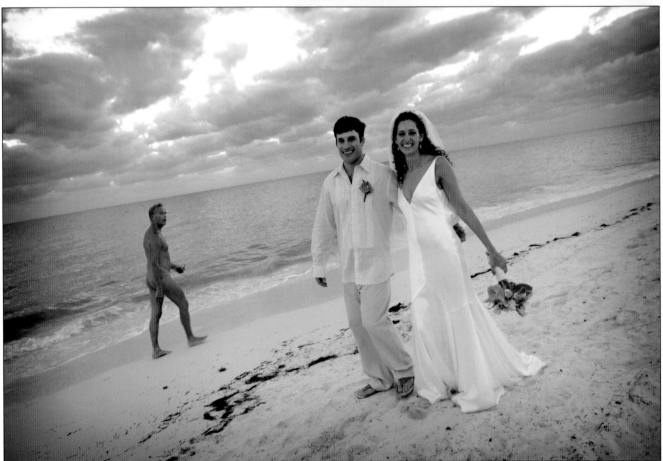

Becker's sense of timing is exquisite, but this is not just a "grab shot." There are elements that are truly beautiful—the vignetting, the near transparent rendition of the water, the priceless expressions of the bride and groom, the look of the passerby, and the beautiful rendition of the clouds overhead.

6. COLOR MANAGEMENT AND DEVICE PROFILING

Whether you are doing your own printing or working with a lab, you need an efficient and precise system of color management. This guarantees that what you see on your monitors will be matched as closely as possible in color and density to the final output.

Jeff Smith, an award-winning photographer and author from Fresno, CA, is like most photographers who have made the transition from film to digital. His workflow model with labs was well established and he was happy with years of beautiful printing from negatives. Jeff's studio simply cut the negatives, marked the order, and sent it off to the lab. The next time he saw the order, it was beautifully finished and ready to package and deliver. If the order wasn't right, the lab would redo it. When his lab switched over to digital, though, he found he was not getting the quality he had gotten for the last 15 years. "Purple skin wasn't the look we were going for," he said.

With digital, Smith and company had to take over doing all the work, but were charged the same price for digital output as printing from negatives. This meant that the lab bill stayed the same, but Jeff needed to employ additional people to prepare the files for the lab.

Smith investigated inkjet and dye-sublimation printers and found either the quality, cost, or time to produce prints wasn't to his liking. Smith started to fantasize about the Fuji Frontier, the Rolls Royce of digital printers. He found, instead, an all-in-one digital printer/paper processor: the NetPrinter from Gretag. The Netprinter, as well as other digital printers from other makers, are self-contained printers/processors that print

The GretagMcBeth Eye One spectrophotometer comes with a convenient ruler guide and backing board so that the colored wedges of the test print can be read quickly and accurately. The data is then processed to create an ICC profile that gets loaded into the computers that are printing to a specific printer with the profiled paper.

This is a standard printer calibration target, courtesy of Claude Jodoin. Claude sent me this target as a file, which I then printed with my Epson Photo Stylus 2200 printer. I sent the print back to Claude, who then created a profile, which I installed when he e-mailed it to me. From that day on, I had the paper I normally use perfectly profiled. The color and print density showed marked improvements after the system was profiled. Each paper you use needs its own unique profile.

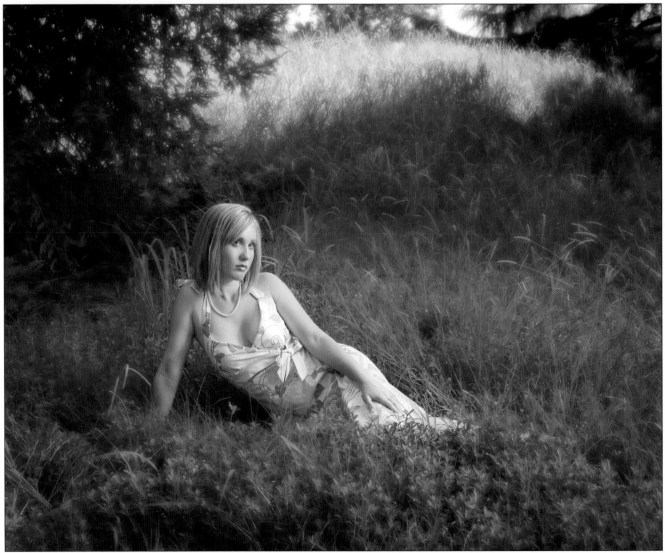

Skin tone and color balance are perfect in this outdoor senior portrait by Jeff Smith. As Smith recalls, it took quite awhile to get everything calibrated, but once it was, everyone on his studio's staff could make perfect prints on the Netprinter.

on almost any photographic paper. Smith's Netprinter outputs up to 12x18-inch prints at 500dpi for an average cost per 8x10 of 35–45 cents per print—and, the machine can print up to 200 prints per hour.

So what does this story have to do with color management? Well, what Smith found out was that even though the Netprinter came loaded with ICC profiles for the most popular papers, the studio wasn't getting consistent results. In the end, what Smith ended up doing was purchasing Eye One Calibration software to calibrate each monitor and write specific ICC profiles for the machine. This got the monitors close to the final output on paper, but still the staff, as a group, had to learn to interpret the subtle differences between the colors and contrast of the monitors and how they reproduced on specific papers.

Today, Jeff's staff is trained to interpret color, the customers are happy, and he's happy too. According to Smith, "For our studio this was a necessary step to make digital as profitable as shooting with film."

By mixing red, green, and blue (RGB) colored light in varying proportions and intensities, a large percentage of the visible spectrum can be represented. RGB devices, including most digital cameras, scanners and monitors, use red, green, and blue light to reproduce color. A color-management system performs two important functions: (1) it interprets these RGB (or CMYK) values and (2) it maintains the appearance of those colors from one device to another consistently—from input, to display, to output.

So why, even in a color-managed system, does the print sometimes look different than the screen image? The answer lies not so much in the color-management question, but in the differences between media. Because monitors and printers have a different color gamut (a different fixed range of color values they can produce or display), the physical properties of these two different devices make it impossible to show exactly the same colors on your screen and on paper. However, effective color management allows you to align the output from all of your devices to simulate how the color values of your image will be reproduced in a print. This begins with device profiling.

OPTIMAL VIEWING

It is recommended that you set your computer desktop to a neutral gray for viewing and optimizing images. Because you will most likely make adjustments to color and luminosity, it is important to provide a completely neutral, colorless backdrop to avoid distractions that might affect your critical ability to judge color. Since I deal with tens of thousands of images each year, my monitors all are optimized with neutral gray backgrounds. It's not as exciting as wallpaper, but it helps keep my sense of accurate color balance intact. To optimize your working area, the room lighting should also be adjusted to avoid any harsh, direct lighting on the monitor. This will allow more accurate adjustments to your images and will reduce eyestrain. Attempt to keep ambient light in the room as low as possible.

■ MONITOR PROFILES

If you set up three identical monitors and had each display the exact same image, the images would all look a little bit different. This is where profiles come into play. Profiling, which uses a hardware calibration device and accompanying software, characterizes the monitor's output so that it displays a neutral or at least a predictable range of colors.

A monitor profile is like a color-correction filter. Going back to the example of the three monitors above, one monitor might be slightly green, one magenta, and one slightly darker than the other two. Once the monitor is calibrated and profiled, and the resulting profile is stored in your computer, however, the profile will send a correction to the computer's video card, correcting the excess green, magenta, and brightness, respectively, so that all three monitors represent the same image identically.

Monitor profiling devices range from relatively inexpensive ($250–$500) to outlandishly expensive (several thousand dollars), but it is an investment you cannot avoid if you are going to get predictable results from your digital systems.

Camera profiles can be somewhat impractical under general shooting conditions. This is because most scenes vary wildly, so whatever aspect of the scene the photographer wants to emphasize or de-emphasize can be controlled—but not by a generic system of settings. Take this blue interior by Chris LaLonde for example. He shot it in RAW mode and made the following adjustments in Adobe Camera Raw: White balance: 5000°; tint: +1; exposure: −0.05; shadows: 9; brightness: 59; contrast: +95; saturation: +15; sharpness: 25; color noise reduction: 86. The list goes on and on, but the point is that very specific adjustments were important to this scene that might not be important to the next scene photographed. This flexibility is why RAW is fast becoming the file format of preference.

■ CAMERA PROFILES

DSLRs are used in a wide variety of shooting conditions. This is especially true in wedding photography, where the photographer may encounter a dozen different combinations of lighting in a single afternoon, all with varying intensities and color temperatures. The wedding photographer is looking at a world of color.

Just as all monitors are different, all digital cameras vary at least a little in how they capture color. As a result, some camera manufacturers, like Canon, don't provide device profiles for their cameras. After all, if the manufacturer made one profile for all their cameras, it would prove somewhat useless. Additionally, there are software controls built into the setup and processing modes for each DSLR that allow photographers sufficient control to alter and correct the color of the captured image.

Creating these custom camera profiles is beneficial if your camera consistently delivers off-color images under a variety of lighting conditions, captures skin tones improperly, or fails to record colors accurately when such precision is critical, such as in the fashion and garment industry. Commercial photographers, for exam-

Gamma. Gamma refers to the monitor's brightness and contrast and represents a known aim point. For example, if your video card sends your monitor a message that a certain pixel should have an intensity equal to x, the monitor will actually display a pixel that has an intensity equal to x. Typically, monitors used with Macs have a default gamma setting of 1.8, while monitors used with PCs and Windows have a default setting of 2.2. Both operating systems allow gamma to be adjusted, which can be important if your lab is using a different gamma than you. Also, both systems have built-in self-correction software to optimize the accurate appearance of images.

ple, often use camera profiles to satisfy the color rendering needs of specific assignments.

One of the most inexpensive and effective camera profiling systems is the ColorEyes profiling setup. It is simple enough, albeit time consuming. Basically, you photograph a Macbeth ColorChecker (a highly accurate and standardized color chart) and create a profile using ColorEyes software. The software looks at each patch and measures the color the camera saw. Next, the software calculates the difference between what the camera saw and what the reference file says the color is supposed to be. Third, the software builds the profile, which is actually a set of corrections to make the camera "see" more accurately.

While the wedding photographer would not necessarily profile each camera used on each location, a camera profile might prove useful in a studio setting where a specific set of strobes produces consistently off-color results. That profile would not apply for any other situation than that studio and those lights, but it is more convenient than other means of color correction.

Fortunately, most digital cameras are manufactured so that their color gamut is very close to a universal color space, such as sRGB or Adobe RGB 1998. Color space is a type of universal profile. Anytime a file is sent from one person to another (or from you to your lab), it should be in one of these universal color spaces. (*Note:* Most labs have a preferred color space. Usually

The bumpers on this Jaguar image looked like plastic to the client, so they were retouched to look like chrome, as shown here. The Brush tool in Photoshop was used to create this effect and the Smudge tool was used to smear the highlights for a starburst effect. The retouching was done in RGB because the retouching artist, Glenn Honiball, was uncertain of the many possible final destinations for the image.

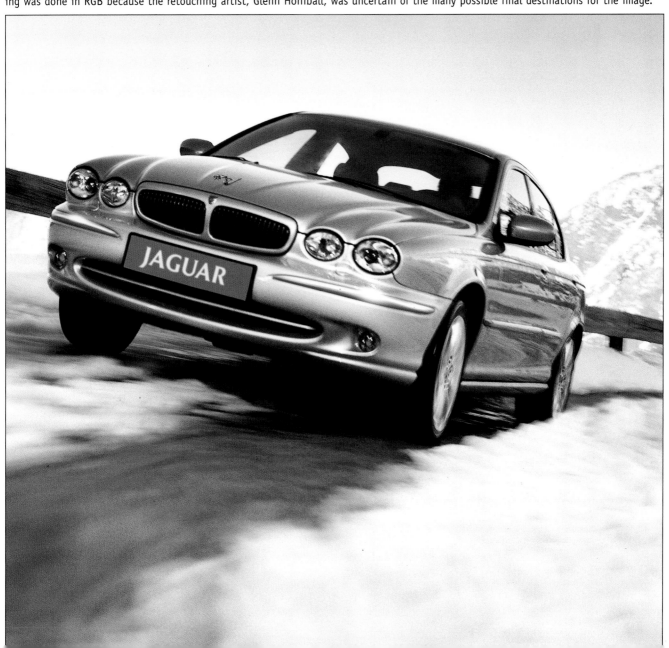

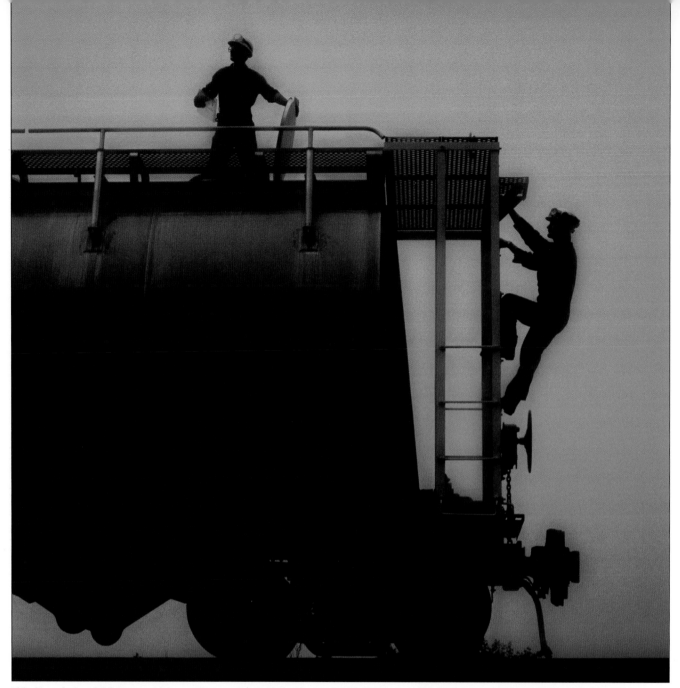

This is an industrial image used in a corporate brochure for Nexen Chemicals. It was shot with a Haselblad 500C/M, 150mm lens and daylight transparency film with an orange filter on the lens. It was scanned right away and the color mode of CMYK and the working CMYK color profile of U.S. web (coated) SWOP 20% assigned to the file. These choices were made because the image's final destination was a four-color printed brochure on coated paper. Photograph by Christian LaLonde.

this is sRGB, but not always. Check with your lab to make sure your files are using the correct color space.)

■ PRINTER PROFILES

Printer profiles are built by printing a set of known color patches from a special digital image file. A spectrophotometer is then used to read the color patches so the software can interpret the difference between the original file and the actual printed patches. This information is stored in the form of a printer profile, which is then applied to future prints to ensure they are rendered correctly. Custom printer profiles ensure that you are getting the full range of colors that your printer can produce. For best results, use a unique custom profile for each inkjet paper you use.

Custom profiles, such as the Atkinson profiles, which are highly regarded, can be downloaded from the Epson website (www.epson.com) and a variety of other sites.

Here's how it works: go to the website, then download and print out a color chart. Mail it back to the company, and they will send you a profile or set of profiles via e-mail.

Another great source of custom profiles for a wide variety of papers and printers is Dry Creek Photo (www.drycreekphoto.com/custom/customprofiles.htm). This company offers a profile-update package so that each time you change your printer's ink or ribbons (as in dye-sublimation printing) you can update the profile. Profiles are available for inkjets, dye-sub printers, and small event printers (Sony); Kodak 8500- and 8600-series printers, Fuji Pictography, RA-4 printers (Light-Jet, Durst Lambda/Epsilon, Fuji Frontier, Noritsu QSS, Gretag Sienna, Kodak LED, Agfa D-Lab, etc.); Color Laserjets and Thermal printers. (*Note:* Most of the expensive commercial printers that labs use include rigorous self-calibration routines, which means that a single profile will last until major maintenance is done or until the machine settings are changed.)

■ SOFT PROOFING

Output profiles define your printed output, as well as your ability to "soft proof" an image intended for a specific printer. A soft proof allows you to see on the calibrated monitor how an image file will appear when

This delicate image by Kersti Malvre is a perfect candidate for soft proofing. If you have various paper profiles in your system that are profiled to your printer, you can compare the soft-proofs to best decide which paper is the most appropriate for this image.

This image of the Eiffel Tower by Jeff Kolodny looks very different when soft-proofed. In CMYK, the image has a deeper black and more image contrast. In Monitor RBG, the image looks flatter and less saturated. The Soft Proof option is a great tool for determining the look of your printed output, regardless of the device or system that will be used. Soft proofing is also an economical alternative to test prints, especially when using expensive fine-art papers.

a printing press, viewed on a particular computer operating system, made into color separations, and produced on a specific output device. You can even open the document in two different windows so you can compare the colors in the original image file and the colors in the soft proof.

To display a soft proof: Choose View>Proof Setup, and choose the profile of the color space that you want to simulate. Most are self-explanatory, but here are a few of the choices:

Custom: Creates a soft proof of colors using the color profile of a specific output device or of specific papers used in a desktop printer. This option is recommended for the most accurate preview of your final printed piece.

Working CMYK: Creates a soft proof of colors using the current CMYK working space as defined in the Color Settings dialog box.

Working Cyan Plate, Working Magenta Plate, Working Yellow Plate, Working Black Plate, or Working CMY Plates: Creates a soft proof of specific CMYK ink colors using the current CMYK working space.

Macintosh RGB or Windows RGB: Creates a soft proof of colors in an image using either a standard Mac OS or Windows monitor as the proof profile space to simulate. Neither of these options is available for Lab or CMYK documents.

Monitor RGB: Creates a soft proof of colors in an RGB document using your current monitor color space as the proof profile space (unavailable for Lab and CMYK files).

Simulate Paper White: Previews the specific shade of white exhibited by the print medium defined by a document's profile.

Simulate Ink Black: Previews the actual dynamic range defined by a document's profile. This option is not available for all profiles and is available only for soft-proofing, not for printing.

printed to a specific profiled output device. By referring to an output profile in an application like Photoshop, you can view out-of-gamut colors on your display prior to printing. Needless to say, accurate output profiles can save time, materials, and aggravation.

Previewing Colors Using a Soft Proof. If your monitor is properly calibrated and you have accurate profiles of your output devices, you can use Photoshop's soft-proofing capabilities to see how your image will look when printed on your desktop printer, sent to

7. WORKFLOW METHODS

The wedding photographer's workflow for a film-captured wedding is quite different from the digital photographer's workflow. The tasks include the same things—proofing,

printing, retouching, and so forth, but the way the individual tasks are accomplished is quite different and unique from photographer to photographer.

■ MICHAEL AYERS' BASIC WEDDING WORKFLOW
FOR HIGHEST QUALITY JPEGS

This example of a basic workflow comes courtesy of Michael Ayers, an award-winning photographer from Ohio. It assumes that the files were captured as highest quality JPEGs. (The RAW file workflow pattern is involves RAW-file processing, but would be very similar other than that.) Ayers' workflow is a good model because it includes printed proofs, a virtual proof album on CD, and uploading low-resolution JPEGs to a website for general viewing and purchase by guests and relatives.

Uploading. After the images have been captured, the CF cards or removable media are assembled and the process of uploading the JPEG files to your computer's hard drive can begin. FireWire or USB 2.0 card readers are recommended for this purpose, as their connectivity speed allows you to upload large numbers of image files quickly. Files should be uploaded to folders, which can be broken down according to chronology or function—1. Pre-Wedding, 2. Wedding, 3. Reception, and so forth. Some photographers name these file folders 1000, 2000, 3000, etc., so that files named with those prefixes will be instantly recognizable as "Wedding," "Reception," and so forth.

File Backup. All image files should be backed up onto CD-ROMs at this point; these are your source files—your originals. Many photographers use DVDs, as their capacity is much greater and all of the folders can be copied onto one disk. You may also consider a portable hard drive as a suitable backup device.

Edit and Adjust. Michael Ayers always shoots extra copies of some images, especially groups, to insure that he has captured everyone looking their best. At this stage, he goes into the computer browser (Microsoft XP filmstrip browser, Adobe Photoshop file browser, Photoshop CS2's Bridge) to edit the images. Any poorly exposed images or duplicates are deleted at this point. Some exposures may need color adjustment or contrast changes. At this point in the process, Ayers will adjust

PRINTING OPTIONS

Many photographers have the equipment and staff to print their own wedding images in house. It gives them the individual control over the process that even the best labs cannot provide. Other photographers have devised interesting ways to save money by employing the lab's wide-format printers. David Williams, for example, uses a lab called The Edge, in Melbourne, Australia. The Edge uses a Durst Lamda Digital Laser Imager, which produces continuous-tone images on photographic media straight from Macintosh or PC files. Williams prepares Photoshop files of finished album pages, panoramas, small prints and proofs on a 32-inch wide file (the width of the lab's Lamda), utilizing every square inch of space. The 32x32-, 32x50-, or 32x70-inch files are output at one time very inexpensively. The lab even trims all of the images for Williams, thus increasing his productivity and

David Williams "gangs" his finished album pages on a 32-inch wide file at 400dpi. This image was a 153MB JPEG. His lab, The Edge, outputs the already fine-tuned images as a single print on a 32-inch wide Lamda digital printer. The lab even trims the prints for him.

lowering his costs. David follows the guidelines of the lab and works in Adobe RGB (1998) at the gamma recommended for either PCs or Macs. The files may be TIFFS or JPEGs at 200 or 400 dpi. The Edge will even provide a calibration kit on request to better coordinate your color space to that of the lab's.

these images in Photoshop's Levels or Curves. He will also fix obvious problems, removing EXIT signs, adjusting odd compositions, etc.

Image Manipulation. It's at this point that Ayers begins to "play" with the images in Photoshop, using various plug-ins and actions to creatively alter the images. Some will be turned into monochrome or sepia-tone images, some will get selective coloring. The full gamut of creative effects is open to him.

Rename. To this point, most images have been saved as high-quality JPEGs; Ayers has not saved any of the images more than once, so there's no loss of quality from the originals. If he plans on manipulating an image further, however, he saves it as a TIFF file. When

all images are finished and in order, he uses either Photoshop or CompuPic Pro to do a Batch Rename on all the files. His system calls for a three-digit serial number plus the extension, for example: 001.JPG, 002.JPG, 003.JPG.

Some photographers choose to rotate the images at this point for proper orientation. Programs such as ACDSee, EZViewer, or Thumbs Plus are powerful browsers used in conjunction with Photoshop. You can use them to rotate a display of images.

Copy Again. Once the Photoshop work is complete, Ayers makes another set of copies of the finished files in their folders. This time he makes the copies to an external portable hard drive, using either USB 2.0 or

Firewire connectivity for fastest transfer. Ayers recommends disconnecting this hard drive from the computer and storing it unplugged in another location.

Proof Setup and Printing. For proofing, Ayers' studio provides pages placed into a 10x13-inch General Products album binder. These 10x13-inch proof pages are printed "nine-up" (three rows of three), so each image is about 3x4 inches with a border. He creates these using the Picture Index function in CompuPic Pro, which takes only a few minutes. There are other programs that will create similar proofs, including Photoshop (File>Automate>Contact Sheet II). Ayers

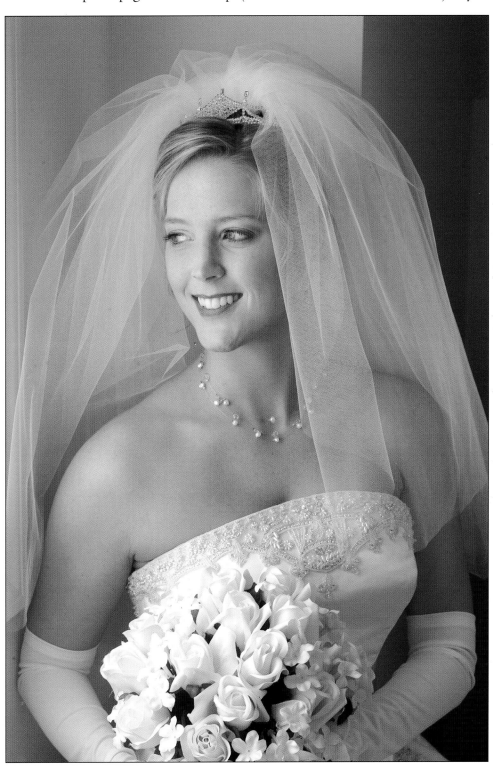

Ayers' workflow is based on shooting highest quality JPEGs with a Fujifilm FinePix DSLR. This image was shot with a 50mm lens at ISO 400.

By uploading his images to Eventpix.com, an online hosting/ordering service, Ayers has substantially increased his print orders.

sometimes prints these pages out on his Fujifilm PG 4500 printer, otherwise he sends them to his lab.

FlipAlbum. FlipAlbum Pro is a program used to create attractive digital proof books on CD-ROM. Ayers first copies all of the finished images in his wedding folders into a folder called the FlipAlbum folder. The images will become the basis for the virtual proof book made with the FlipAlbum Professional software. Having a complete but separate folder for these images is a necessary step and a safeguard against damaging or changing any originals from the wedding folder.

All images in this folder get resized to 1200x800 pixels. Ayers uses Photoshop's Batch controls (File> Automate>Batch) and saves these images as low-quality JPEGs at the "3" quality setting—good enough for screen viewing. This ensures the FlipAlbums will run at peak speed and require little disk space on a CD-R.

At this point, Ayers goes through the images in the FlipAlbum folder, highlighting the vertical ones. He then opens them in Photoshop and batch rotates them using an easy-to-create Photoshop action, so all are properly oriented on screen. Every one of these photographs is now oriented correctly and will be used not only for the FlipAlbum CD-Rs but also as the images to upload to the Eventpix.com website later in the process.

Special features of FlipAlbum include the ability to show panoramas, an index, and table of contents,

and security options like password protection, expiration date, and anti-copy/print functions. Ayers generally builds several of these CD-Rs so that the couple and significant family members can have them to choose images and place orders.

Uploading to the Internet. There are a number of Internet companies that will display your wedding photos online and even handle online ordering and fulfillment for you. Ayers uses Eventpix.com, because he says it is fast and secure for his clients to use. He finds that using the site has resulted in many additional orders per wedding from people who would normally never have even viewed the event's originals! He usually uploads about 150 images and leaves them up for about two months.

Consolidate Orders. All orders received online, by fax, by phone, or from the couple are consolidated into a big print order in a separate folder for Ayers' lab using Fujifilm's Studiomaster Pro software. Studiomaster Pro lets a customer build an order that goes directly to your lab and provides all the tools you need to create a dazzling studio preview for your clients. It also allows cropping, resizing, and retouching to be done to your images before printing. Later, album orders are also arranged into orders and even "Smart Pages" using this software. Ayers raves about this workflow package, claiming it is quickly becoming the key to his studio's productivity. (*Note:* Kodak's comparable software, Pro Shots, is currently in its sixth generation and is also quite popular with many labs and photographers.)

Thumbnails. Contact Sheet II in Photoshop allows Ayers to print out tiny thumbnails of all of the couple's favorites, which are now in a folder called "Album Choices." He prints these little images on adhesive-backed paper and cuts them up into little stickers. He says of this method, "I've used many album design soft-

ware programs in the past and this manual option gives me greater flexibility with my creative pages."

Album Layout. Ayers schedules an appointment for the couple to review the album choices, then they stick the thumbnails down onto squares, which represent the pages of the album—almost like playing Scrabble! The couple usually has a lot of input as he shows them his ideas. The album will be built exactly as they have envisioned it.

Retouching. With all the orders and albums ready to be printed, Ayers goes through each photograph one last time to check color and fix any problem, such as blemishes, glasses glare, stray hairs, shiny faces, and even "blinks" are corrected here, if possible.

Ordering. Ayers' orders from Studiomaster Pro are sent directly to his lab using CDs or FTP (File Transfer Protocol). Most orders are processed and returned in just a few days without rush service charges. All images are printed on a Fujifilm Frontier on Fuji Crystal Archive Paper.

Album Ordering. Ayers then faxes the order for the album cover, mats, inserts, and panorama pages to General Products, a Chicago album company. This is another area that differs greatly among photographers; Ayers prefers mats and inserts, other photographers prefer digitally generated, hand-bound albums.

Print Sorting. When prints come back from the lab, the quality and quantity are checked. Then the prints are separated with each person's orders. The album prints are put in order with the layout forms so they can be placed in mats quickly. Missing or damaged prints are noted so they can be sent back with the next order to the lab. All client orders are placed on the studio's work-in-progress shelves in the studio production room.

Folders and Mounting. Ayers' studio uses folders for 5x7-inch and smaller prints, which come from General Products. Larger individual prints are mounted on premium-quality mount board. Ayers believes that presentation is very important if you charge a premium

Michael Ayers' wedding albums are exquisite traditional volumes put together with a very modern and streamlined digital workflow.

for your work, so get the best photo mounts available for reasonable prices! All album prints are placed in General Products mats and bonded permanently into the inserts, which are placed into the album cover.

Shipping. Many of Ayers' wedding clients live out of town. If they are local, though, he sets up a special time to present their album and deliver other related orders, as well. Otherwise, he'll ship the finished products in specially lined boxes.

Archiving. Finally, the entire set of folders is archived to DVD. Michael always make sure everyone is finished ordering first, and he also tests this final DVD on another computer to make sure that it operates perfectly. He is now ready to delete this set of folders from the hard drive to make room for new weddings. He stores final DVDs in archival-quality containers (like jewel cases) in a cool, dark, and safe place.

■ JERRY GHIONIS' ALBUM WORKFLOW

Jerry Ghionis owns and operates XSight Photography and Video in Australia. His studio does a thriving wedding business and Ghionis has been able to design a specialized workflow that keeps the album production really humming. With his brother Nick and wife Georgina, both partners in the business, plus five full-time employees (including a digital production specialist, a digital artist, a color analyst, and an album coordinator), the studio is capable of producing five albums a week. Says Ghionis, "Our whole post-production workflow has been digital for about seven years. Whether the wedding

has been photographed digitally or shot on film and then scanned, every single image goes through the computer."

There are six stages in producing an album within XSight's workflow.

1. Pre-design for the perfect album is done with TDA Albums Australia software. (*Note:* TDA software is a drag-and-drop template system supplied to customers using Albums Australia albums.)
2. The album and the sales order are finalized with the clients.
3. Copy all the images from the CDs or hard drives to folders for cleaning and color correcting.
4. Double check the cleaning, tweak the color, choose effects, resize images, etc.
5. Design the pages, check for digital quality control, burn the image to CD and send the files to the lab.
6. Assemble the album.

Rather than having everyone produce an album from start to finish, Jerry believes it's important that everyone does what he or she does best and get even better at it.

Clients are quoted 10 weeks production time, although the studio's internal schedule suggests that they are capable of producing an album within seven to eight weeks. Ghionis says of the timetable, "We allow a buffer of two weeks in case of any delays or any unforeseen circumstances from our suppliers so that we don't have to upset an eager client. The client doesn't know about the buffer, so if everything is on time, we often pleasantly surprise them with news that the album is ahead of schedule."

FACING PAGE—Jerry Ghionis' wedding albums are designed in a very logical and orderly fashion. These books are highly regarded by his clients—and other professional photographers—and earn Ghionis' studio top dollar.

◼ CHRIS LALONDE'S ON-LOCATION WORKFLOW

Chris LaLonde is a successful commercial photographer and, as such, an expert problem solver. He is not tied to digital or to film, he doesn't prefer daylight over strobe, or tungsten lights over either—he chooses whatever best fulfills the requirements of the job. He is often on assignment with client and art director in tow, looking over his shoulder. Moments like these can be stressful and unproductive, but LaLonde has incorporated his teammates into his workflow, making them as important a part of the process as his technical expertise.

When shooting digitally, he uses Nikon D2X digital cameras tethered to a 21-inch Apple G4 PowerBook. This is a large laptop screen that is also extremely sharp, which is ideal for close-up analysis of the image. If the shot requires special cropping, he uses a cropping mask on the laptop screen to duplicate the ad specifications. A series of test shots are made and input given from the client and/or art director, who may or may not like what they see. The important aspect is that the process truly becomes a team effort.

Unlike in the past, when the client looked at Polaroids, which rarely resembled the final transparency film, the final image is in the computer and opened in Photoshop before anyone leaves the scene. The client/art director may even be able to take a CD-R of the final image with them.

LaLonde likes the control afforded by shooting in RAW mode and, since the final product is usually a single image, he will take the time to tweak the file on screen so it looks its absolute best. LaLonde is as resourceful in Photoshop as he is with his lighting, so the

This group portrait is actually a montage made up of three individual shots stitched together in Photoshop. The head chef and bottom row is one image; the middle and top rows are separate images. All three images were made with natural light plus a 600 watt-second White Lightning bounced into a 4x8-foot white Fome-Cor board. The strobe was kept two stops less than the main exposure of f/5.6 just to add evenness and fill-in. All shots were done with a Kodak SLR/n and 50mm f/1.4 Nikkor lens and captured to a G-4 laptop.

ABOVE—This is one of six images done for a big hotel chain by Chris LaLonde. Each image had to have some kind of movement. The lighting was a mix of ambient and window light, but Chris still needed a kicker (backlight) on the male model. He used a 4x8-foot white panel to light up the background and model. He made sure that the image was a little overexposed on the chairs and background area by using an extra softbox coming in from the back right. The large window on the left, being overexposed, provided a great movement effect because of the white space against the almost silhouetted model. His team did several tests at various exposures, and ¼ second gave them the best results with the model's walking speed. When on location, Chris always carries a laptop on which clients can see the just-photographed images. He shoots right into the laptop and the large screen is great for proofing with the clients. He usually places a cropping mask onto the

screen to show what the final format will look like. In this case, all of the six images were to be panoramic in the billboard format. This image blew the clients away as soon as they saw it. RIGHT—Nikon WT-2A transmitter on the D2X body. Images can be so quickly downloaded and ramped up for projection that wedding guests cannot believe their eyes.

image becomes a final image before the client's eyes. Before the set is struck, the team agrees that the assignment is right and that the job is done.

■ MIKE COLÓN'S WIFI WORKFLOW

Today's wedding clients expect immediacy. They aren't content with seeing proofs four weeks after the honeymoon. As a result, Newport Beach wedding photographer Mike Colón has revised his wedding workflow so that he can deliver wedding photos at the wedding reception—even photos taken *during* the reception.

Mike has each of his Nikon D2H cameras fitted with a Nikon WT-1A wireless transmitter. As he shoots, the WT-1A automatically sends each to an Apple G4 PowerBook, which comes with a built-in WiFi transceiver. It takes about two seconds for each image to transfer. At the same time, the images are still being written to the CF cards in the camera as backup.

During the ceremony, Mike's assistant with the PowerBook stays within transmitting range (typically about 100 feet, although the optional Nikon WA-E1 extended antenna can transmit up to 450 feet from the camera) and checks the images as they are being shot in real time. Once he has a good number of images, Colón's assistant begins to create a slideshow. Near the end of the reception, Mike then uses a digital projector

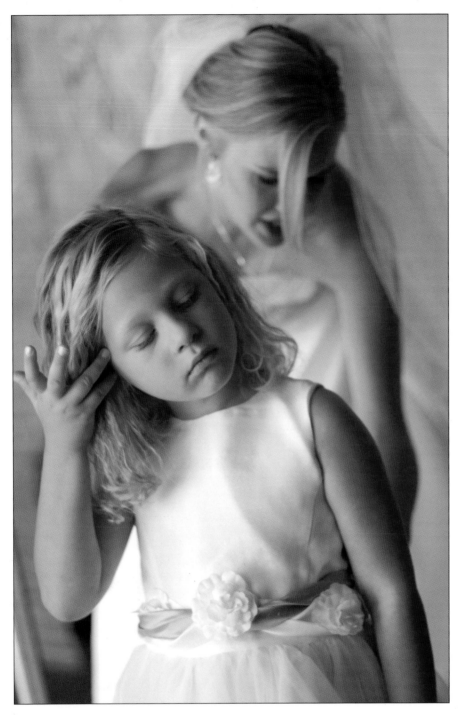

Mike Colón has a great eye in addition to his outstanding technical skills. Here, Mike stacked the two figures so that you see both the similarities and differences between them. Notice the subtle separation of the little girl's dress against the pure white wedding dress in the background. Without this minor detail, the image would not communicate so effectively.

to produce a show for the guests. Images captured right up to the start of the slide show can be incorporated into the presentation. Mike says the surprise of seeing the images immediately really delights both the guests and the bride and groom. Not surprisingly, he finds the spontaneity often makes guests more likely to order prints. If it's not possible to project the slide show, he will show the images directly on the PowerBook.

While all this is going on, Colón also selects key images that he outputs as 4x6-inch prints on a Mitsubishi dye-sub printer. At the end of the wedding, he places these in a mini album that the bride and groom can take with them on their honeymoon.

8. ADOBE PHOTOSHOP

Adobe Photoshop is much more than a powerful program for editing image files, it is a virtual digital darkroom that offers more creative flexibility than a conventional darkroom. And better than darkroom work, Photoshop allows you to work on the image as a positive (rather than a negative) so you can preview the effect as you create it.

Photoshop's flexibility also makes it open to a wide variety of unique creative techniques. In fact, if you sit down with six photographers and ask them each how they do a fairly common correction, like selective diffusion, you just might get six completely different answers. Many practitioners pick up one technique here and another at a workshop they've attended and, the next thing you know, the two techniques have become hybridized to produce a slightly different result than was yielded by either of the original methods.

The following is a collection of Photoshop techniques gleaned from the photographers who appear in this book.

■ PHOTOSHOP TOOLS

Actions. An action is a series of commands that you record as you perform them, then play back to apply the same functions on another image or set of images. The Actions palette is accessed under the Window menu. To create an action, select New Action from the fly-out menu at the top right corner of the Actions palette. You will be asked to name it, then you can start recording by clicking the record button at the bottom of the palette. Once you are recording, everything you do to the image will be recorded as part of the action. When done, simply stop recording. Whenever you want to perform that same action, you can access it in the Actions window. When you hit the play button, the action runs on the open image. Most commands and tool operations are recordable in actions. Actions can also include stops that let you perform tasks that cannot be recorded (for example, using a painting tool) and modal controls that let you enter values in a dialog box while playing an action.

Photoshop comes with a variety of preloaded actions you can use as is or customize to meet your needs. You can also purchase actions from reliable sources on the Internet to utilize the experience of some of the best Photoshop practitioners in the business. For example, Fred Miranda has a site (www.fredmiranda.com) that

contains a wide variety of excellent actions at reasonable prices. Two of Miranda's more noteworthy actions are SI Pro II (short for Stair Interpolation Pro), which al-lows you to increase file size and dimensions, and Intellisharpen II, which is a smart-sharpening action that gives you 12 sharpening options with full previews.

Here, the original image (left) is flat and there is no real modeling to the lighting on their faces. In the second image (below), we see several actions in use: PortraitPopper, Shadow-Soft Natural, Facial Enhancements, Porcelain-Skin, DarkEdge Strong, Fashionizers Strong, and UnsharpMask Medium. Selective darkening was also applied around the subjects and bright areas with local lightening on subjects. The edge details were enhanced with Fashionizer's built in masks. This image sequence is by Craig Minielly, MPA. The actions used on it were designed by Craig and are available at www.craigsactions.com.

Layers. Layers allow you to work on one element of an image without disturbing the others. Think of layers as sheets of acetate stacked one on top of the other. Where there is no image on a layer, you can see through to the layers below. You can change the composition of an image by changing the order and attributes of its layers. In addition, special features such as adjustment layers, fill layers, and layer styles let you create sophisticated effects. You can also put multiple layers together in different ways. Groups let you view, manipulate, and assign attributes to multiple layers as a single object.

Duplicate the Background Layer. Make it your practice to duplicate the background layer before getting started working on an image. This preserves the original, which floats to the bottom of the Layers palette. It also opens up creative possibilities, allowing you to alter the new layer and then lower its opacity to allow the original to show through.

Name Each Layer. Get into the habit of naming each layer. This will help you to organize and work with multiple layers. Photoshop names layers for you by default, but it's much more logical to work with names of your own choosing. Double-click on the layer name to rename it (up to 63 characters long).

Opacity and Blending Options. A layer's opacity and blending options determine how its pixels will interact with pixels on the underlying layer. The opacity of a layer determines how much it obscures or reveals the layer beneath it. A layer with 5-percent opacity is nearly transparent, while a layer with 100-percent opacity appears completely opaque. Blending modes determine how a layer's pixels blend with underlying pixels in the image. You can create a variety of special effects using blending modes.

The blending mode of a single layer is set, by default, to normal. With layer groups, the blending mode is set to pass through, which means the layer group has no blending properties of its own. When you choose a different blending mode for a layer or layer group, you effectively change the order in which the entire image is composited. All of the layers in a layer group are composited first. The composited layer group is then treated as a single image and blended with the rest of the image using the blending mode selected.

Jim DiVitale is a master at working in layers. In this image called *Madonna,* you can see the various layers being transmitted and blocked so that to appreciate the image one must go deeper into the layers as opposed to a surface review in two dimensions.

Linked Layers. If you have a number of layers that you want to move around the image, link them. You can link two or more layers or groups. Unlike multiple layers selected at the same time, linked layers retain their relationship until you unlink them. You can move, apply transformations, and create clipping masks from linked layers. To link layers, select more than one layer or group in the Layers palette, then click the Link Layers icon (chain link) at the bottom of the Layers palette. Click again on the icon to unlink them.

Filling New Layers. Some filters (such as the Lighting Effects filter) cannot be applied to layers having no pixels. Selecting the "Fill with (Mode)-Neutral Color" in the New Layer dialog box resolves this prob-

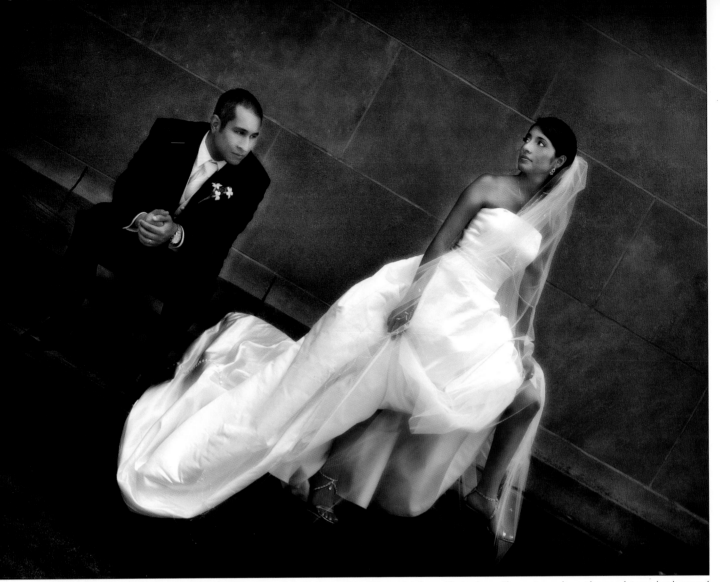

Jim Fender created this beautiful wedding portrait with a considerable assist from Photoshop. Elements such as the sandstone background and steps were minimized with layers to darken them, accentuating the bride and groom. Her dress was also treated with great care, bringing out all of the detail and texture in the material.

lem by first filling the layer with a preset color. The neutral color is assigned based on the layer's blending mode and is effectively invisible. If no effect is applied, filling with a neutral color has no effect on the remaining layers. To activate this option in the New Layer dialog box, switch the mode to something *other* than Normal, Dissolve, Hue, Saturation, Color, or Luminosity.

Layer Styles. Layer styles let you quickly apply certain effects to a layer's content. You can scan through the variety of predefined layer styles and apply one with the click of the mouse, or you can create a custom style by applying multiple effects to a layer.

Adjustment and Fill Layers. Adjustment layers allow you to apply color and tonal adjustments to an image without permanently changing the pixels in the image.

The color and tonal changes exist only within the adjustment layer, which acts as a veil through which the underlying image layers can be seen. An adjustment layer affects all the layers below it. This means that you can correct multiple layers by making a single adjustment, rather than making the adjustment to each layer independently.

Fill layers let you add color, patterns, or gradient elements to an image without changing the pixels in the image itself. Unlike adjustment layers, fill layers do not affect the layers beneath them.

Adjustment layers and fill layers have the same opacity and blending mode options as image layers and can be rearranged, deleted, hidden, and duplicated in the same manner as individual image layers.

RIGHT—Says Rich Nortnik of his art, "With most of the pieces I do, I end up with 90 layers or more. I don't like to flatten anything I have done to a layer because at the end, I might want to go back and change something." **BELOW**—Kersti Malvre created this image with multiple layers and preserved them by saving it as a PSD. Here are some of the individual layers she created: duplicate layer with Dynamic Skin Softener effect, duplicate layer with "Soft Diffuse Glow" of "YervantPortraitPerfect" set; adjustment layer with curves adjustment; layer mask with various brushes applied; new duplicate layer with saturation applied . . . you get the idea.

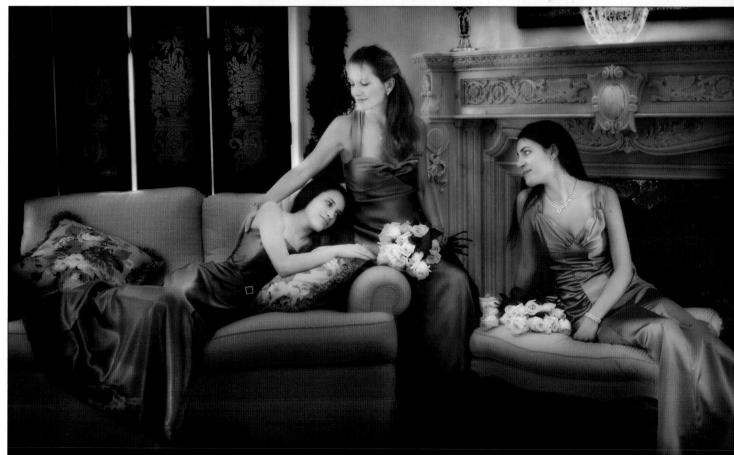

Layers Palette Enhancements

A Linked layers indicator
B Normal layer thumbnail
C Smart Object thumbnail
D Link layers button

This Layers palette shows: linked layers (A), a normal layer thumbnail (B), a Smart Object (*Note:* Smart Objects are a feature of Photoshop CS2 that allow nondestructive scaling, rotating, and warping of raster and vector graphics) thumbnail (C), and the Link Layers button (D).

Layer Masks. Layer masks are used to temporarily hide portions of a layer. By default, adjustment layers and fill layers have layer masks, as indicated by the mask icon to the right of the layer thumbnail. To create a layer mask on another layer (other than the background layer) activate the layer and click on the layer mask icon (the circle in a square) at the bottom of the Layers palette. A layer mask icon will appear beside the layer thumbnail in the Layers palette. With black as your foreground color, you can then use the Brush tool to paint away (conceal) details in the upper layer, allowing the underlying layer to show through. To reveal the hidden areas again, change the foreground color to white and paint the areas back in.

Layer Groups. If you have multiple layers in your image, layer groups (folders that contain layers) will help keep things organized. To create a layer group, click on the folder icon at the bottom of the Layers palette to add an empty folder, to which you can drag layers, forming a group. Or, if you prefer, you can link a series of layers together, then choose New Group From Linked from the Layers palette menu.

Healing Brush and Clone Tool. To remove small blemishes, dust spots, marks, or wrinkles, select the Healing Brush tool. When this tool is selected, an options bar will appear at the top of the screen. Select the Normal mode and Sampled as the source. Choose a soft-edged brush that is slightly larger than the area you are going to repair. Press Opt/Alt and click to sample a nearby area that has the same tone and texture as the area you wish to fix. Then, click on the blemish and the sample will replace it. If it doesn't work, hit Command + Z (Edit>Undo), then resample another area and try again. The Healing Brush differs from the Clone tool in that the Healing Brush automatically blends the sampled tonality with the area surrounding the blemish or mark. However, the Clone tool can be very useful for concealing blemishes in areas where you find that the Healing Brush has problems accurately blending the tonalities from the surrounding areas.

Liquify Filter. The Liquify filter lets you push, pull, rotate, reflect, pucker, and bloat any area of an image. The distortions you create can be subtle or drastic, which makes the command a powerful tool for retouching images as well as creating artistic effects. The best way to control your results is to begin by making a selection with the Lasso tool. Then go to Filter>Liquify. When your selection comes up, you'll see that it has a brush with a crosshair in it. In the panel to the right, you can adjust this brush size for more precise control. Gently push the area that you want to shrink or stretch, gradually working it until you form a clean line. When you're done, hit Enter. You will return to the original image with the selection still active—but with your modifications in place.

■ BASIC RETOUCHING TECHNIQUES

Soft Focus. Once all your retouching is done, merge the visible layers (Layer>Merge Visible). This takes everything you've done so far and reduces it to a single layer.

Duplicate this layer, then apply the Gaussian Blur filter with a radius setting of about 25 pixels, so that the entire image is blurred. Reduce the opacity to about 50 percent for a true soft focus lens effect, a soft image atop a sharp image.

Selective Soft Focus. After applying the soft focus effect (above), click the Layer Mask button to create a mask. With the Brush tool selected and the foreground color set to black, start painting away the diffusion from areas like the teeth, eyes, eyebrows, hairline, lips, and bridge of the nose. By varying the brush size, hardness,

opacity, and flow you will easily restore sharpness in these critical areas while leaving the rest of the face pleasingly soft. The best thing is that there will be no telltale sign of your retouching. When you are done, flatten the layers.

Vignetting. Make a new layer and fill it with black. Adjust the opacity back to about 35 percent so that the image looks dimmed. Add a mask to the layer and then, using a circular black-to-white gradient with the Gradient tool, click near the eyes and drag outward toward the image edge and release the mouse. The

This composition, called *Color Theory II,* drew on memories of a Color Theory class Rich Nortnik Jr. had in college. Of this image he says, "I wanted to experiment with many shades of color, so I started out with a set of Pantone swatches I was using for a project at work. I brought the swatches forward by placing them onto a, then adding a bevel and light shadow for a special effect. I used different color modes on each layer to see what kind of response I could achieve. Then I added different shapes to give it interest. The background of this piece is where I spent most of my time, though—stacking unusual textures, pictures, and color on top of each other, then committing color layer modes, opacity, and color adjustments to the actual layer."

Photoshop CS2's Lens Correction, which is found under Filter>Distort.

result will be a full vignette with the face lighter than the edges of the image.

Straightening Verticals. One of the most amazing things Photoshop does is found under the Edit>Transform menu. Using these tools, you can correct architectural verticals in an image. Here's how:

Open your image and make it smaller than the surrounding canvas area (you can do this by reducing the percentage view at the lower left of the image window, or by moving the slider in the Navigator window). Turn your rulers on (View>Rulers). Click on the horizontal or vertical ruler at the edge of the image and drag a rule into position, placing it on the edge of one of the crooked lines so you will be able to gauge when the line has been straightened. Then, select the entire image (Select>All) and go to the transform function (Edit>Transform>Skew). When you do this, handles will appear on all four corners. Holding down your Option key and dragging on one of the handles allows you to push or pull one edge independently of the others. By doing so, you can correct the vertical or horizontal lines within the image. When the lines are straight, press Return or Enter and the image will process.

Lens Correction. You can also correct a wide range of common lens distortion flaws from a single interface in Photoshop CS2. You can eliminate barrel or pincushion distortion, chromatic aberration, vignetting, and perspective flaws in all three dimensions—and do it in one pass with simple, intuitive controls, a live preview, and an alignment grid.

Photoshop CS2's optical lens correction (Filter>Distort>Lens Correction) lets you remove the distortion caused by either wide-angle lens use or bad perspective. This mini-application lets you correct verticals more easily than Free Transform. You can also:

- Use the Zoom tool to magnify edges in the image to more easily correct chromatic aberration or vignetting, and the Move Grid tool to adjust the alignment grid.
- Use the Edge menu to determine how the edges of the transformed image are filled, or use the scale slider to expand the image and fill in the edges.
- Use the Distortion tool to correct distortion by dragging in the image.

- Use the Straighten tool or angle setting to straighten the image by rotation.

Sharpening. As most Photoshop experts will tell you, sharpening is the final step in working an image, and one of the most common flaws in an image is over-sharpening. Photoshop's sharpen filters are designed to focus blurry or softened images by increasing the contrast of adjacent pixels. This means that you can easily over-sharpen an image and compress detail out of an area or even the entire image.

The most flexible of Photoshop's sharpening tools is the Unsharp Mask filter (Filter>Sharpen>Unsharp Mask). In the Unsharp Mask dialog box, the amount field determines how much to increase the contrast of the pixels. The radius setting refers to the number of pixels surrounding the edge pixels that will be affected by the sharpening; a lower value sharpens only the edge pixels, whereas a higher value sharpens a wider band of pixels. The threshold setting is used to specify how different the sharpened pixels must be from the surrounding area before they are considered edge pixels and sharpened by the filter. The default threshold value (0) sharpens all the pixels in the image.

The best method for using this filter is to convert the image to the Lab Color mode (Image>Mode>Lab Color). In the Channels palette, click on the lightness channel to deselect the A and B channels (the image will look black &

white). Use the Unsharp Mask filter to sharpen only that channel, then restore the A and B channels by clicking on the composite Lab channel at the top of the Channels palette. Go to Image>Mode to convert the image back to the desired mode, and you will be amazed at the results.

Another way to effectively use the Unsharp Mask filter is to apply it to just one channel in an RGB image. To see the difference this makes, duplicate your image (Image>Duplicate) and place the two identical windows side by side on your screen. On one image, apply the Unsharp Mask to the image without selecting a channel. In the Unsharp Mask dialog box, select amount: 80 percent; radius: 1.2 pixels; threshold: 0 levels. On the second image, go to the Channels palette and look at each

In this unusual work of art, entitled *Far, Far From My Heart,* Jim Fender employed various visual elements to reveal a "trapped" spirit. My favorite element is the almost invisible eye between the two skyscrapers in the background.

channel individually. Select the channel with the most midtone data (this is usually the green channel, but not always) and apply the Unsharp Mask filter to it using the same settings. Then, turn the other two channels back on. Enlarge a key area, like the face, of both images to exactly the same magnification—say 200 percent. At this level of sharpening, you will probably see artifacts in the image in which all three layers were sharpened simultaneously. In the image where only the green channel was sharpened, you will actually see a much finer rendition.

■ BASIC COLOR AND TONAL CORRECTIONS

Selective Color. Many people like to use Curves to color correct an image, but there are also those who prefer the Selective Color function (Image>Adjustments>Selective Color). It is among the most powerful tools in Photoshop. This tool does not require you to know in advance which channel (R, G, or B) is the one affecting the color shift. It only requires you to select which color needs adjustment—reds, yellows, greens, cyans, blues, magentas, whites, neutrals, or blacks. Once you've selected the color you want to adjust, use the slider controls (cyan, magenta, yellow, and black) to make the needed correction. (*Note:* Make sure the method mode is set to absolute, which gives a more definitive result in smaller increments.) If, for example, you select reds, no other colors in the scene will be changed by any adjustments you make using the slider bars.

Skin tones are easy to correct using Selective Color, as well. Most caucasian skin tones are comprised of varying amounts of magenta and yellow. Usually when skin tones are off, they can be easily corrected by selecting neutrals, then experimenting with either the magenta or yellow sliders. In outdoor images, you will sometimes pick up excess cyan in the skin tones; this is easily dialed out in selective color.

The Selective Color tool is also useful for eliminating color casts on wedding dresses, which often reflect a nearby color—particularly if the material has a sheen. Outdoors, the dress might go green or blue, depending on whether shade or grass is being reflected into it. To correct the problem, select the whites. Then, if the dress is blue or cyan, add a little yellow or remove a little cyan and judge the preview. If the dress has gone green, add a little magenta and perhaps remove a slight amount of yellow. Often, wedding gowns are treated with brighteners that make the dress almost seem to fluoresce. While this is an attractive trait to the naked eye, to the imaging sensor or film, the dress often goes blue or a mix of cyan and blue. Selective Color is a simple way to color correct just the dress and nothing else in the scene.

FACING PAGE—A variation of the technique of mixing color and black & white in the same image is seen in this image by Jeffrey and Julia Woods. The bouquet and boardwalk are rich saturated color, while the sky and water have been desaturated to give them a monochrome look.

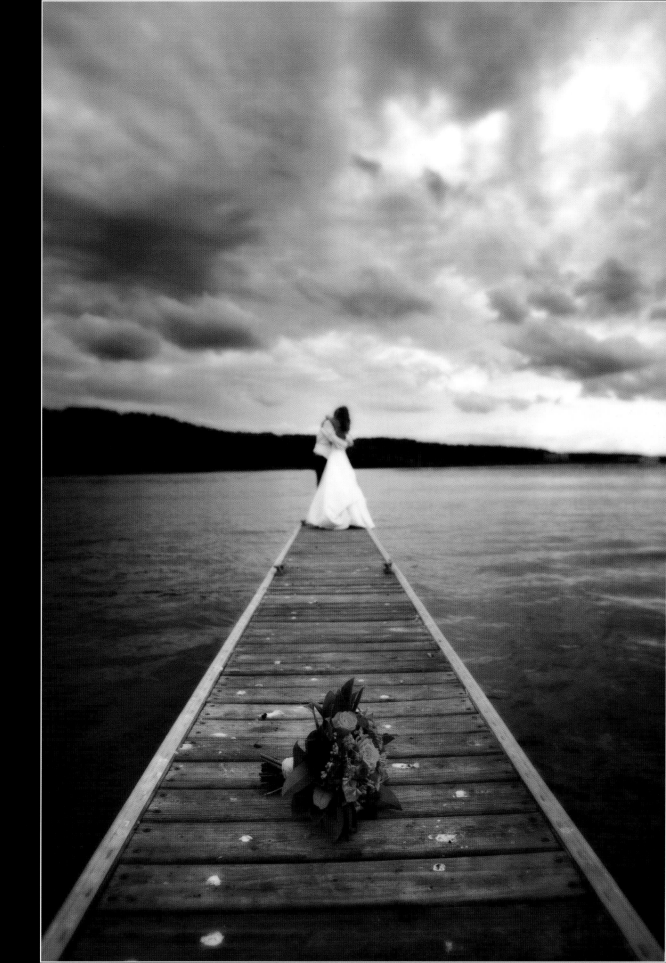

THIRD-PARTY PLUG-INS

Plug-ins are programs developed by Adobe, and other software developers in conjunction with Adobe Systems, to add features to Photoshop. A number of importing, exporting, and special-effects plug-ins come with Photoshop; they are automatically installed in the plug-ins folder.

You can select an additional plug-ins folder to use compatible plug-ins stored with another application. Alternately, you can create a shortcut (Windows) or an alias (Mac) for a plug-in stored in another folder on your system, then add the shortcut or alias to the plug-ins folder to use it with Photoshop.

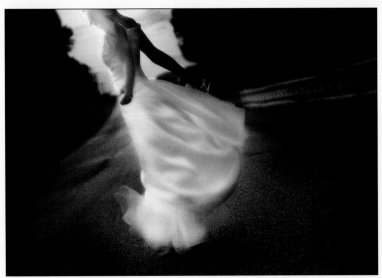

This elegant bridal image was treated with a variety of Photoshop plug-in filters and actions to create a masterpiece of fine art. Photograph by Jeffrey Woods.

Once installed, plug-ins appear as options added to the Import or Export menu, as file formats in the open and Save As dialog boxes, or as filters in the filter submenus. Photoshop can accommodate a large number of plug-ins. However, if the number of installed plug-ins becomes too great, Photoshop may not be able to list all the plug-ins in their appropriate menus. Newly installed plug-ins will then appear in the Filter>Other submenu.

In Selective Color, the black slider adds density to the image. Be sure to use the black slider *only* when adjusting the Blacks channel, otherwise it will fog the image. When converting images from RGB to CMYK, the black slider in Selective Color is very useful for adding the punch in the blacks that is missing after the conversion.

With the Selective Color command, you can also create a selection and color correct only that area. For teeth, for example, a loose selection around the mouth will do; then adjust the whites by subtracting yellow. It's a quick and effective means of whitening teeth.

Targeting White and Gray Points in Levels. Go to levels (Image>Adjustments>Levels) and select the white point eyedropper. Using this tool, click on a white area in the scene—a white point on the bride's wedding dress, for example. One click will not only color balance the whites, but it will bring any color shifts that may exist in the flesh tones back in line. The same technique will work well when using the gray point eyedropper

(also in found in the levels) on a neutral gray area of the photograph.

When an image doesn't have a well-defined gray or white point, you cannot use this method of color correction. Instead, create a new layer and go to selective color (Image>Adjustments>Selective Color). Correct the neutrals by adding or subtracting the appropriate color(s), then adjust the opacity of the new layer. You will get more subtlety than if you tried to correct the entire image.

Shadow/Highlight. Photoshop's Shadow/Highlight control is an ingenious method for controlling shadow and highlight density in any 8- or 16-bit RGB, LAB, or CMYK image. For an underexposed image where the highlights are okay, make a layer copy and go to Image>Adjustments>Shadow/Highlight. The default setting is almost too much, so reduce the Shadows setting down to a realistic level. Then, make another copy of the corrected layer and create a layer mask to help you selectively adjust the shadows.

■ COLOR ENHANCEMENTS

Sepia/Blue Tone. Whether your image is Grayscale or RGB, create a Background Copy Layer as in many of the steps above. Working on that layer, go to Image>Adjustments>Desaturate to create a grayscale image. Adjust in Levels at this point, if so desired. Next, go to Selective Color (Image>Adjustments>Selective Color). Go to the Neutrals channel and begin dialing in various amounts of magenta and yellow. More magenta than yellow will give you a truer sepia tone. More yellow than magenta will give a brown or selenium image tone. The entire range of monochrome warm toners is available using these two controls.

If you want to a cool-toned image, add either plus cyan or minus yellow or both. Again, a full range of cool tones is available in almost infinite variety.

Once you have created a number of image tones you like, create actions for them using Desaturate and then Selective Color and the exact values for each adjusted color.

Mixing Color and Black & White in the Same Image. A popular effect is to add bits of color to a monochrome image. This technique is done by duplicating the background layer, then desaturate the duplicated layer by going to Image>Adjustments>

This is an image by Jeffrey and Julia Woods that uses soft color mixed with more vibrant color for an unusual effect.

This before and after example includes all of the techniques described here. The original digital image was so sharp that it needed softening so that the face would not be so incredibly detailed. Even people with exceptional eyesight do not experience others' features in this way. Photographs by Claude Jodoin.

Desaturate. After desaturating, go to the Levels control to adjust brightness and contrast to your liking. Then choose the Eraser tool (set to a small to medium-sized soft brush and 100-percent opacity) and start erasing. In the areas where you erase the desaturated layer, color from the original, underlying background layer will show through.

Soft Color. This is a technique that mutes the colors in an image. To achieve it, duplicate the background layer and convert it using Image>Adjustments>Gradient Map. Choose a black-to-white gradient for a full-tone black & white image. Blur the underlying color layer using the Gaussian Blur filter with a radius setting of about 12 pixels. In the Layers palette, reduce opacity of the black & white layer to about 65 percent. Add another adjustment layer (Layer>New Adjustment Layer>Photo Filter), then vary the setting of the filter for a range of colored effects.

■ **PROFESSIONAL PHOTOSHOP TECHNIQUES**
Claude Jodoin's Facial Retouching. Claude Jodoin is an award-winning wedding and portrait photographer whose digital-retouching techniques are highly esteemed. The following are some of the operations he frequently performs when retouching portraits.

Eliminating Blemishes. Jodoin enlarges the face to 100 percent and selects the Patch tool. Then, he simply surrounds the blemish and drags it to an adjacent area of skin. This removes the blemish while maintaining the same general color and texture of the skin.

Smoothing the Skin. To smooth the skin, Jodoin creates a rough selection around the face and copies it onto a new layer. Using a filter called Airbrush Gem Professional from Kodak, he selects a default value of 60 percent to airbrush the sharpness and pores out of the face. If the correction goes too far, he reduces the opacity of the layer or uses a layer mask to restore sharpness as necessary.

Enhancing the Eyes. Jodoin begin this process by creating a Curves Adjustment Layer and lightening the overall image by about 20 percent. He then creates a layer mask and fills it with black to mask the entire image. To brighten the eyes, he paints on the mask with white, using a small brush set to about 15 percent opacity. He paints very gradually, lightening the whites of the eyes without making them completely white. The presence of blood vessels in the eyes is realistic and should not be eliminated entirely. (*Note:* By creating another Curves Adjustment layer that darkens the image, you can reapply the same technique to increase the color contrast between the pupil and the iris.)

An alternate technique for lightening the whites of the eyes is to use the Dodge tool (in the Options, be sure to set the range to highlights and select a small brush). With the Burn tool and a small brush, you can darken the very edge of the iris to produce a more

dynamic look and burn in the pupil to make it more stark.

Marcus Bell's Fine-Art Color Effects. Marcus Bell is known across two continents as a master photographer. In his native home, Australia, he has been named Landscape Photographer of the Year, Wedding Photographer of the Year, and Portrait Photographer of the Year—an unheard of accomplishment.

Marcus takes a color image, whether it's a scan or digital original, and converts it to Grayscale to produce

Here is the original scan (right) and the final rendition (below) after Marcus Bell has worked his magic.

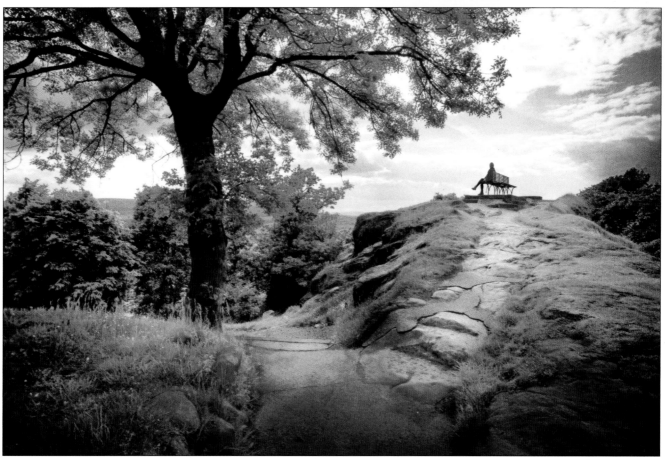

a monochrome image. It is here he begins the process of image reconstruction.

The first step is to clean up the image, removing any dust and scratches. Bell works in steps and saves versions of his progress so that if he is unhappy with any outcome, he doesn't have to start all over at the beginning.

The next step is to bring the image alive in terms of tone and contrast. In the darkroom, when working with a negative, a printer will dodge and burn select areas. Bell does exactly the same using Photoshop. He also likes to make selections and then uses Levels to control how light or dark the area is. Selections are often feathered, sometimes as much as 150 pixels, so the transitional areas are invisible to the naked eye. By selectively darkening and lightening certain areas, he can add shape to the photograph and make it more dimensional. He's also able to maintain detail in the shadow areas, emphasize the center of interest, and create leading lines.

As a practice, he makes a copy of the background layer and then works on the copy, leaving the original untouched underneath. This way he can always revert to the original image. Once he's made adjustments in the selection, the surrounding, unchanged areas are deleted so just the adjustment sits on top of the base image. The process is repeated for each area, so in the end he might have five or more layers, each representing a lightening, darkening, or change in contrast to a particular area. When the process is finished, he can save this file with layers for archival purposes, then open a new version of the file and flatten it before continuing.

At this stage, Bell has a high-quality black & white image, but his ultimate product will be a color photograph. Why start from a black & white? Well, Bell reasons that if he can't get the image to flow in monochrome, he has little chance of making it work in color. On the other hand, a photo that works well in black & white can be even *better* with the use of the right colors—and this is where he adds color. "I've learned a lot about the use of color by studying artists, especially Jeffrey Smart [a widely exhibited Australian artist now living in Italy]," Bell says. "These artists use color as a compositional element, and with Photoshop, photographers can do the same."

ABOVE—In order to make the bride and groom the focal points of this composition, he left their color data intact and made the surrounding hillsides and vineyard more or less monotone; at least within the same palette. **FACING PAGE**—Sometimes Bell will leave part of the image in black & white for emphasis or mood. This is what he did here to the sky, giving it an ominous, foreboding look.

After converting grayscale image to RGB mode, he selects the areas he wants to work in using the Lasso tool and then opens up the Color Balance dialog box to produce the desired color. By using layers for each area, he can always return to adjust the color, without affecting everything else in the image. Bell works almost like a painter, starting with a blank canvas and adding color according to the message or emotion he wishes to convey without being influenced by what was originally there. He doesn't use color for the sake of creating a

pretty picture, but rather to emphasize different aspects within the image. "By choosing colors that complement or oppose each other," says Bell, "you can take control of your image, guiding the eye as you please and adding weight to certain elements over others."

He sometimes needs to do a little dodging and burning after adding color or the result will look a bit flat, and selections are lightly feathered—2 to 10 pixels—so the colors blend together naturally. He can also use the opacity control on each layer to reduce the strength and change the weight, so his choice of color can be subtle or strong. Another tool he likes is the Brush tool in color mode.

Marcus is amazed how this approach has changed his work. "I find I'm looking at my work in a totally new light," he says. "Images I might have passed over before now have me thinking, 'Wow!'"

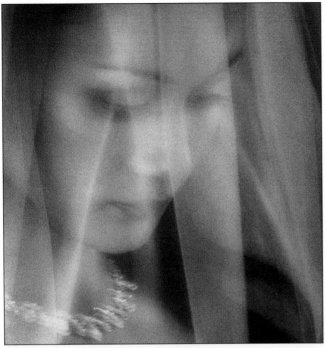

LEFT—Sometime Marcus just wants a cool tone monochromatic look, as was done here. **BELOW AND FACING PAGE**—Then there are times when Bell wants only to enhance the colors that exist in his scene. The gray sky in the wedding image is enhanced and the white balance in the portrait of the older gentleman has been set to daylight, allowing the warm room lights in the background to add atmosphere.

Wendt took two decades to photograph this Aston Martin DB9 . . . well, not really—but he first discovered the location twenty years earlier and had never used it until he discovered the right time of year (May), the right day of the week (Sunday, when nobody was around), and the right time of day (very early morning). He always knew this location was capable of producing an incredible image, so he had to wait for the right car, as well. The Aston Martin, with its long, low lines and glass-like paintwork, proved to be the secret ingredient. Wendt used a Canon EOS-1Ds Mark II, 70–200mm f/2.8 Canon lens at the 200mm setting, and RAW mode. He used Photoshop to blend and build the highlights in the bodywork and multiple layers to house each phase of the artwork.

David Wendt's Layers Techniques. David Wendt photographs cars, and planes, and trains, and just about anything that moves—but he chooses his subjects wisely. They are rare examples of each breed and he turns his collections into calendars and hopefully, someday, books.

Wendt is a little different from most photographers in that he's got complete control over the final piece. To him it's "very liberating and I suspect it's very rare." So he considers himself lucky to have such control. Once he gets a few shots he likes for his calendar projects, he starts manipulating the image in Photoshop, which he runs on an Apple G5 with lots of RAM. He uses an Apple 23HD flat-screen monitor, a product he loves.

In Photoshop, Wendt uses layers to build color and contrast. He wants warmer and cooler colors to work together to separate one thing from another. He likes to blend cool colors, which tend to recede visually, and warm colors, which tend to advance. The blending helps to produce contrast and vivid color. He sometimes makes a duplicate layer, adjusts it to be cooler, then uses layer masking to erase the cooler layer and let the warmer base layer show through. This technique tends to "cool off" the background.

Wendt also uses blurring to create contrast. For example, he might take that same duplicate layer that he just cooled off, duplicate it again and use Gaussian Blur to "knock back the focus." The results can be very

interesting, especially once he adds a little noise to restore texture to those areas. This slight amount of noise also makes the image look sharper than the original. (*Note:* After he's added noise, Wendt often returns to the blur filter again and slightly softens the noise.)

Wendt spends a lot of time on the wheels, which often reflect their surroundings and pick up the colors surrounding the scene. He gets good results when he opens a new empty layer and paints over isolated parts of those reflections with warm or cool flat colors. Skies with sunsets are great reflector panels for most cars, but the colors can get lost in the details of the wheels. Painting on flat colors and then adjusting the layer opacity and blending mode of the painted layer can help accent these tones.

MAKING CONTACT SHEETS

Photoshop has a fairly sophisticated method for making proof sheets. Simply go to File>Automate>Contact Sheet II. From the dialog box that appears, choose the folder of images from which you want to make the proof sheets. Then, select a resolution and color mode (RGB is the default mode). Select the size and font that you want the file names to appear in (or if you want to turn that feature off) and the number of rows and columns—3x3, 4x4, 2x3, etc.—that will be used on the proof page. Hit OK and the contact sheets will be produced automatically.

To shoot this vintage 1934 MG-NA David Wendt jury-rigged a mounting system, which allowed him to position a camera in close proximity to the moving MG. Wendt ended up towing the MG with his Audi and created two rolls of 220 film of varying exposures. The two "final" exposures were a frozen sharp image and a blurred image. He had the film drum scanned and then combined the images in Photoshop. Using layers, he erased the blurred image of the car to reveal the sharp image underneath. He left all the blurred areas alone to convey fast motion. He also rebuilt the area in Photoshop that showed the rigging and camera support.

About this photographic montage, *Radio Wars*, DiVitale says, "The most important talent to develop for an illustrative photographer in the digital age is previsualization. Being able to see images in mutable layers takes this creative process to the next level."

While on a Photoshop lecture tour, DiVitale stayed a few nights on the Queen Mary in Long Beach, CA. While wandering around on the ship with his camera, he found a display room with antique radios. "The room was very dark, and I didn't have a tripod with me, so I raised the ISO to 800 and set the white balance for tungsten. I pressed the lens right up to the glass window to brace the camera and shot one-second exposures of the different radios in the room as RAW files. The files were then processed in Photoshop's Adobe Camera RAW.

Using the old telephone line switchboard as a background anchor layer, he outlined each of the radios with the Pen tool, turned them into selections, and brought them into the image as layers, one image at a time. He then blended the different radio images together using different layer modes and opacities. Some of the layers were duplicated a few times with different combinations of blend modes to get the translucent effect. Additional tiny grid lines and type were added with different blend modes for added image depth.

Jim DiVitale Knows When Size Matters. For over 25 years, Jim DiVitale has been involved with multiple imagery, previsualizing how multiple images can work together and combining then with pin-registration and now digitally. As an advertising photographer working for Coca-Cola, he learned how to mask one background and insert another—taking the bubbles from one drink shot and combining them in another, for example.

DiVitale also espouses the use of RAW file imaging and brags that he can take a 2MB file and blow it up to

500MB. "If you know how to do it right, it works perfectly" he says. He believes that most digital shooters don't quite get the idea of RAW files. They start shooting JPEGs for speed and when they blow things up, the images fall apart because there's no data there. From his top-quality RAW files, DiVitale is able to make Duratrans transparencies, trade show displays, and large-scale images as big as 40-feet long. You just have to know the right techniques in Photoshop.

The best way to increase the size of images is to up-sample the image in small increments, otherwise known as stair interpolation. This method of up-sizing is preferable to increasing image size in one large step, say from 100 directly to 400 percent. The concept of stair interpolation is simple: rather than using the Image> Size command to go from 100 to 400 percent in one step, you use the command in small increments, increasing the image by perhaps 10 percent at a time and repeating it as many times as it takes to get to the size you need. As you do this, alternate the resampling mode between Bicubic, Bicubic Sharper, and Bicubic Smoother. If you want to enlarge an image from 5x7- to 8x10-inches for example, be sure to check Scale Styles, Constrain Proportions, and Resample Image. Change the 7-inch dimension to 7.5 inches and click OK. Repeat in half-inch increments until your image is the desired size. You may or may not need to sharpen the image when you're finished.

Obviously, this can be tedious if your software does not have some automation capability. Fred Miranda's SI Pro and Resize Pro are stair interpolation plug-ins for Photoshop that solve this problem by automating the resizing process. You enter the size increase or the desired dimensions, specify sharpening or not, and the image is quickly enlarged—and it is almost indistinguishable from the original.

Jim Divitale has a great design sense combined with an amazing grasp of the technical. This image is simply titled *Glasses*.

CONCLUSION

When I first started out in professional photography in 1972, we used 6x7 Koni-Omega rangefinder cameras and 120 Tri-X souped in Acufine at a film speed of 1600. It was a shock, coming out of photo school, where fine grain and full-range tonality were the expected standard. But we all have to learn the differences between the theoretical and the practical; between what we learn in school and what we learn on the job. But nothing in my wildest imagination could have prepared me for what we now casually call the "digital revolution." It was a changing of the guard so complete and so vast that the economic destinies of Fortune 500 companies have shifted and reversed and an entirely fresh wave of new-technology companies has swept across the photographic landscape. As dramatic as the economic changes that digital technology has created are, they pale in comparison to the profound changes in how professional photographers view their craft. Techniques that were once difficult or nearly impossible are now commonplace and the creative horizon has stretched farther than anyone could have anticipated.

There are few, if any, imposed ceilings anymore. As we imagine new ways of seeing the world, so we create the images that redefine it. That is the true beauty of digital—technology feeding creativity. Different disciplines, like cinema, graphic design, and multimedia are now merging full throttle into photography. Fine art blends with classical portraiture and soon there are literally no boundaries.

One might think that with this great technical revolution comes a dismissal of the traditions and practices that were and are the foundation of conventional photography. Not so. The traditions carry on with unexpected nuances and a blending of what is expected and what is unexpected.

Perhaps the most telling truth now evident in this time is that that there is, more than ever before, no roadmap of what comes next. But one thing is certain: it's going to be fun!

Action. In Adobe Photoshop, a series of commands that you play back on a single file or a batch of files.

Adobe Camera RAW. The Photoshop Camera RAW plug-in lets you open a camera's RAW image file directly in Photoshop without using another program to convert the camera RAW image into a readable format. As a result, all your work with camera RAW image files can be completely done in Photoshop.

Adobe DNG. Adobe Digital Negative (DNG) is a publicly available archival format for the RAW files generated by digital cameras. By addressing the lack of an open standard for the RAW files created by individual camera models, DNG helps ensure that photographers will be able to access their files in the future.

Adobe RGB 1998. The largest recommended RGB working space. Well suited for print production with a broad range of colors. Widest gamut color space of working RGBs.

Antialiasing. Refers to methods of eliminating or reducing unwanted artifacts such as jagged lines. In the context of images, antialiasing refers to the reduction of the jagged borders between colors.

Barebulb Flash. A portable flash unit with a vertical flash tube that fires the flash illumination 360 degrees.

Barn Doors. Black, metal folding doors that attach to a light's reflector. These are used to control the width of the beam of light.

Bit. Stands for binary digit. Smallest unit of information handled by a computer. One bit is expressed as a 1 or a 0 in a binary numeral. A single bit conveys little information a human would consider meaningful.

However, a group of eight bits makes up a byte, representing more substantive information.

Bit Depth. Number of bits per pixel allocated for storing color information in an image file.

Bitmap Image. Also called a raster graphic, bitmap images are created from rows of different colored pixels that together form an image. Bitmaps are resolution dependent. Examples of bitmap graphic formats include GIF, JPEG, PNG, TIFF, XBM, BMP, and PCX as well as bitmap (i.e., screen) fonts.

Box Light. A diffused light source housed in a box-shaped reflector. The bottom of the box is translucent material. The side pieces of the box are opaque, but they are coated with a reflective material such as foil on the inside to optimize light output.

Bounce Flash. Bouncing the light of a studio or portable flash off a surface such as a ceiling or wall to produce indirect, shadowless lighting.

Burning In. A darkroom or computer printing technique in which specific areas of the image are given additional exposure in order to darken them.

Burst Rate. The number of frames per second (fps) a digital camera can record and the number of frames per exposure sequence a camera can record. Typical burst rates range from 2.5fps up to six shots, all the way up to 8fps up to 40 shots.

Byte. A unit of data consisting of eight bits. Computer memory and storage are referenced in bytes—kilobytes (KB=1000 bytes), megabytes (MB=1 million bytes), or gigabytes (GB=1 trillion bytes).

Calibration. The process of altering the behavior of a device so that it will function within a known range of performance or output.

Catchlight. The specular highlights that appear in the iris or pupil of the subject's eyes, reflected from the portrait lights.

CCD (Charge-Coupled Device). A type of image sensor that separates the spectrum of color into red, green, and blue for digital processing by the camera. A CCD captures only black & white images. The image is passed through red, green, and blue filters in order to capture color.

CF Card. CompactFlash (CF) cards are popular memory cards developed by SanDisk in 1994 that uses solid-state memory to store data on a very small card.

CF Card Reader. A device that is used to connect a CF card or Microdrive to a computer. CF card readers are used to download digital image files from a capture and/or storage device to your computer workstation.

Channel. Used extensively in Photoshop, channels are images that use grayscale data to portray image components. Channels are created whenever you open a new image and accessed in the Channels palette. The image's color mode determines the number of color channels created. For example, an RGB image has four default channels: one for each of the red, green, and blue primary colors, plus a composite channel used for editing the image. Additional channels can be created in an image file for such things as masks or selections.

Chromatic Aberration. A common lens defect in which the lens focuses different frequencies (colors) of light differently. One type of chromatic aberration results in the different colors being in focus, but each color's image point at a slightly different size. This type of aberration results in complementary color fringing in areas away from the center of the image.

CMOS (Complementary Metal Oxide Semiconductor). A type of semiconductor that has been, until the Canon EOS D30, widely unavailable for digital cameras. CMOS imaging chips offer more integration (more functions on the chip), lower power dissipation (at the chip level), and smaller system size as compared to CCD (charge-coupled device), the other major type of imaging chip.

CMYK. In Photoshop's CMYK mode, pixels are assigned a percentage value for each of the process inks. The lightest (highlight) colors are assigned small percentages of process ink colors, the darker (shadow) colors are assigned higher percentages. For example, a bright red might contain 2 percent cyan, 93 percent magenta, 90 percent yellow, and 0 percent black. In CMYK images, pure white is generated when all four components have values of 0 percent.

Color Management. A system of software-based checks and balances that ensures consistent color through a variety of capture, display, editing, and output device profiles.

Color Space. An environment referring to the range of colors that a particular device is able to produce.

Color Temperature. The degrees Kelvin (K°) of a light source or film sensitivity. Color films are balanced for 5500°K (daylight), 3200°K (tungsten), or 3400°K (photoflood).

Cross Processing. With film, developing color negative film in color transparency chemistry (or vice versa). With digital, a Photoshop effect that mimics film cross processing.

Curves. Changing the shape of the curve in the curves dialog box alters the tonality and color of an image. In the RGB mode, bowing the curve upward lightens an image; bowing the curve downward darkens it. The steeper sections of the curve represent portions of an image with more contrast. Conversely, flatter sections of the curve represent areas of lower contrast in an image.

Depth of Field. The distance that is sharp beyond and in front of the focus point at a given f-stop.

Depth of Focus. The amount of sharpness that extends in front of and behind the focus point. Some lenses' depth of focus extends 50 percent in front of and 50 percent behind the focus point. Other lenses vary.

Diffusion Flat. Portable, translucent diffuser that can be positioned in a window frame or near the subject to diffuse the light striking the subject. Also known as a scrim.

Dodging. Darkroom or computer printing technique in which specific areas of the print are given less print exposure, making them lighter.

DPI (Dots Per Inch). Printer resolution is measured by the number of ink dots per inch (dpi) produced by all laser printers, including imagesetters. Inkjet printers produce a microscopic spray of ink, not actual dots; however, most inkjet printers have an approximate resolution of 300 to 2880dpi.

Dragging the Shutter. Using a shutter speed slower than the X-sync speed in order to capture the ambient light in a scene.

E.I. (Exposure Index). The term refers to a film speed other than the rated ISO of the film.

Embedding. Including a color profile as part of the data within an image file. Color space, for example, is an embedded profile.

Emulation Profiles. Characteristic settings used in RAW file converters to emulate certain types of film or other image effects.

EPS (Encapsulated PostScript). File format capable of containing high-quality vector *and* bitmap graphics, including flexible font capabilities. The EPS format is supported by most graphic, illustration, and page-layout software.

EXIF (Exchangeable Image Format). EXIF is a digital imaging standard for storing metadata, such as camera settings and other text, within digital image files. EXIF data is found under File>File Info in Photoshop.

Feathered Edge. Also known as the penumbra; the soft edge of the circular light pattern from a light in a parabolic reflector.

Feathering. (1) Misdirecting the light deliberately so that the edge of the beam of light illuminates the subject. (2) In Photoshop, spreading the selection over a wider area so as to minimize the apparent edge of the selected area.

Fill Card. A white or silver card used to reflect light back into the shadow areas of the subject.

Fill Light. Secondary light source used to fill in the shadows created by the key light.

Flash Fill. Flash technique that uses electronic flash to fill in the shadows created by the main light source.

FireWire. A high-speed interface designed to transfer data at speeds of 400 to 800 megabits per second. FireWire technology transfers data uncompressed in real time.

Flashing. A darkroom technique used in printing to darken an area of the print by exposing it to raw light. The same technique can be achieved in Photoshop using a transparent vignette.

Flashmeter. A handheld incident light meter that measures both the ambient light of a scene and, when connected to an electronic flash, will read flash only or a combination of flash and ambient light. They are invaluable for determining outdoor flash exposures and lighting ratios.

Flat. A large white or gray reflector, usually on castors, that can be moved around a set for bouncing light onto the set or subject.

Focusing an Umbrella. Adjusting the length of the exposed shaft of an umbrella in a light housing to optimize the light output.

Fresnel Lens. The glass filter on a spotlight that concentrates the light rays into a narrow beam of light.

FTP (File Transfer Protocol). A means of opening a portal on a website for direct transfer of large files or folders to or from a website.

Gamut. Fixed range of color values reproducible on a display (e.g., monitor) or output (e.g., printer) device. Gamut is determined by the color gamut, which refers to the actual range of colors, and the dynamic range, which refers to the brightness values.

Gaussian Blur. Filter used to blur a selection by an adjustable amount. Gaussian refers to the bell-shaped curve that is generated when Photoshop applies a weighted average to the pixels. The Gaussian Blur filter adds low-frequency detail and can produce a hazy effect.

Gradient Map. A command that maps the equivalent grayscale range of an image to the colors of a specified gradient fill. If you specify a two-color gradient fill, for example, shadows in the image map to one of the endpoint colors of the gradient fill, highlights map to the other endpoint color, and midtones map to the gradations in between.

Grayscale. Color model consisting of up to 254 shades of gray plus absolute black and absolute white. Every pixel of a grayscale image displays as a brightness value ranging from 0 (black) to 255 (white). The exact range of grays represented in a grayscale image can vary.

Highlight Brilliance. Refers to the specularity of highlights on the skin. An image with good highlight brilliance shows specular highlights (paper base white) within a major highlight area. Achieved through good lighting and exposure techniques.

Histogram. A graph associated with an image file that indicates the number of pixels for each brightness level. The range of the histogram represents 0 to 255 from left to right, with 0 indicating "absolute" black and 255 indicating "absolute" white.

Hot Spots. (1) A highlight area of the image file that is overexposed and without detail. Sometimes these areas are etched down to a printable density. (2) The center of the core of light that is often brighter than the edges of the light's core.

ICC Profile. File that contains device-specific information that describes how the device behaves toward color density and color gamut. Since all devices communicate differently as far as color is concerned, profiles enable the color management system to convert device-dependent colors into or out of each specific color space based on the profile for each component in the workflow. ICC profiles can utilize a device-independent color space to act as a translator between two or more different devices.

Incident Light Meter. A handheld light meter that measures the amount of light falling on its light-sensitive dome.

Interpolation. When an image is resampled, an interpolation method is used to assign color values to any new pixels Photoshop creates, based on the color values of existing pixels in the image. For interpolation, choose: bilinear for a medium-quality method; bicubic for the slow but more precise method, resulting in the smoothest tonal gradations; bicubic smoother when you're enlarging images; and bicubic sharper for reducing the size of an image. This method maintains the detail in a resampled image. It may, however, oversharpen some areas of an image. In this case, try using bicubic.

JPEG (Joint Photographic Experts Group). JPEG is an image file format with various compression levels. The higher the compression rate, the lower the image quality, when the file is expanded (restored). Although there is a form of JPEG that employs lossless compression, the most commonly used forms of JPEG employ lossy compression algorithms, which discard varying amounts of the original image data in order to reduce file storage size.

LCD (Liquid Crystal Display). On digital SLRs, the LCD is used to display images and data.

Levels. In Photoshop, levels allows you to correct the tonal range and color balance of an image. In the levels dialog box, input refers to the original intensity values of the pixels in an image and output refers to the revised color values that are based on your adjustments.

Lighting Ratio. The difference in intensity between the highlight side of the face and the shadow side of the face. A 3:1 ratio implies that the highlight side is three times brighter than the shadow side.

Lossy/Lossless Files. Many file formats use compression to reduce the file size of bitmap images. Lossless techniques compress the file without removing image detail or color information; lossy techniques remove detail.

LPI (Lines Per Inch). Also known as screen ruling or line screen, screen frequency is measured in lines per inch (lpi) or lines of cells per inch in a halftone screen. The higher an output device's resolution, the finer (higher) a screen ruling you can use. The relationship between image resolution and screen frequency determines the quality of detail in the printed image. To produce a halftone image of the highest quality, you generally use an image resolution that is two times the screen frequency.

Mask. In Photoshop, an adjustment tool that sits atop a layer, allowing you to isolate areas of an image as you apply color changes, filters, or other effects to the unmasked part of the image. When you select part of an image, the area that is not selected is "masked" or protected from editing.

Metadata. Metadata (literally, data about data) preserves information about the contents, copyright status, origin, and history of documents, and can be used to search for files.

Microdrive. Storage medium for portable electronic devices using the CF Type II industry standard. Current microdrive capacities range from 340MB to 1GB of storage. The benefit of a microdrive is high storage capacity at a low cost. The downside is the susceptibility to shock—bumping or dropping a microdrive has been known to lead to data loss.

Modeling light. A secondary light mounted in the center of a studio flash head that gives a close approximation of the lighting that the flash tube will produce. Usually high-intensity quartz bulbs.

Monolight. A studio-type flash unit that is self-contained, including its own capacitor and discharge circuitry. Monolights come with internal infrared flash triggers so the light can be fired without directly connecting the flash to a camera or power pack.

Noise. Extraneous visible artifacts that degrade image quality. Image noise is made up of luminance

(grayscale) noise, which makes an image look grainy, and chroma (color) noise, which is usually visible as colored artifacts in the image. Photographing with a higher ISO can result in images with objectionable noise. Luminance smoothing reduces grayscale noise, while color noise reduction reduces chroma noise.

Parabolic Reflector. Oval-shaped dish that houses a light and directs its beam outward in an even, controlled manner.

Penumbra. The soft edge of the circular light pattern from a light in a parabolic reflector. It is also known as the feathered edge of the undiffused light source.

Perspective. The appearance of objects in a scene as determined by their relative distance and position.

Pixel (Picture Element). Smallest element used to form an image on a screen or paper. Thousands of pixels are used to display an image on a computer screen or print an image from a printer.

Plug-Ins. Software programs developed by Adobe and by other software developers in conjunction with Adobe Systems to add features to Photoshop. A number of importing, exporting, and special-effects plug-ins come with Photoshop; they are automatically installed inside the plug-ins folder.

PPI (Pixels Per Inch). Image file resolution is measured in pixels per inch. A typical high-resolution file is 300ppi.

Print Driver. Software that translates data from a device, usually a computer, into instructions that a specific printer uses to create a graphical representation of that data on paper or other media.

Profiling. Method by which the color reproduction characteristics of a device are measured and recorded in a standardized fashion. Profiles are used to ensure color consistency throughout the workflow process.

PSD (Photoshop Document). The default file format in Photoshop and the only format that supports all Photoshop features. The PSD format saves all image layers created within the file.

RAW File. File format that uses lossless compression algorithms to record picture data directly from the sensor without applying any in-camera corrections. In order to use images recorded in the RAW format, files must first be processed by compatible software. RAW processing includes the option to adjust the exposure, white balance, and color of the image while leaving the original RAW picture data unchanged.

Reflected Light Meter. A meter that measures the amount of light reflected from a surface or scene. All in-camera meters are of the reflected type.

Reflector. (1) Same as fill card. (2) A housing on a light that reflects the light outward in a controlled beam.

Resolution. The number of pixels or dots per inch. When printed, higher-resolution images can reproduce more detail and subtler color transitions than lower-resolution images because of the density of the pixels in the images.

RGB (Red, Green, and Blue). Computers and other digital devices handle color information as shades and combinations of red, green, and blue. A 24-bit digital camera, for example, will have 8 bits per channel in red, green, and blue, resulting in 256 shades of color per channel.

Scrim. A panel used to diffuse sunlight. Scrims can be mounted in panels and set in windows, used on stands, or they can be suspended in front of a light source to diffuse the light.

Shadow Edge. Where a highlight and shadow meet on a surface is the shadow edge. With hard light, the shadow edge is abrupt. With soft light the shadow edge is gradual. Also known as the transfer edge.

Sharpening. In Photoshop, filters that increase apparent sharpness by increasing the contrast of adjacent pixels in an image.

Soft Proof. An on-screen preview of the document colors as they will be reproduced on a specified device.

Slave. A remote triggering device used to fire auxiliary flash units. These may be either optical, or radio-controlled.

Snoot. A conical accessory that attaches to a light housing's reflector and narrows the beam of light. Snoots allow the illumination of very small areas with relatively bright light.

Softbox. Same as a box light. Can contain one or more light heads and single or double-diffused scrims.

Specular Highlights. Sharp, dense image points on the negative. Specular highlights are very small and usually appear on pores in the skin. Specular highlights are pure white with no detail.

Spotmeter. A handheld reflected light meter that measures a narrow angle of view—usually from 1 to 4 degrees.

Spot. *See* Spotlight.

sRGB. Color-matching standard jointly developed by Microsoft and Hewlett-Packard. Cameras, monitors, applications, and printers that comply with this standard are able to reproduce colors the same way. Also known as a color space designated for digital cameras. sRGB is suitable for RGB images destined for the web but not recommended for print production work, according to Adobe.

TIFF (Tagged Image File Format). File format commonly used for image files. TIFF files are lossless, meaning that no matter how many times they are opened and closed, the data remains the same (unlike JPEG files, which are designated as lossy files, meaning that data is lost each time the files are opened and closed).

Transfer Edge. *See* Shadow Edge.

TTL-Balanced Fill Flash. System that reads the flash exposure through the camera lens and adjusts flash output relative to the ambient light for a balanced flash–ambient exposure.

Umbrella Lighting. Type of soft, casual lighting that uses one or more photographic umbrellas to diffuse the light source(s).

Umbra. The hot center portion of the light pattern from an undiffused light in a parabolic reflector.

Unsharp Mask. A sharpening filter in Adobe Photoshop that is usually the last step in preparing an image for printing.

USB/USB 2.0 (Universal Serial Bus). An external bus standard that supports data transfer rates of 12MB per second. USB is particularly well suited for high-speed downloading of images from your digital camera straight to your computer. USB 2.0 transfers data at a much greater rate than USB, with a 480MB-per-second rate in a dedicated USB 2.0 port.

Vector Data. Vector images, also known as object-oriented graphics, are constructed using mathematical formulas to describe shapes, colors, and placement. Rather than a grid of pixels, a vector graphic consists of shapes, curves, and lines that together make a picture. Vector images are resolution-independent. Examples of vector graphic formats are PICT, EPS, and WMF as well as PostScript and TrueType fonts.

Vignette. A semicircular, soft-edged border around the main subject. Vignettes can be either light or dark in tone and can be included at the time of shooting or created later in printing.

Watt-Seconds. Numerical system used to rate the power output of electronic flash units. Primarily used to rate studio strobe systems.

White Balance. The camera's ability to correct color and tint when shooting under different lighting conditions, including daylight, indoor, and fluorescent lighting.

Working Color Space. Predefined color-management settings specifying the color profiles to be associated with the RGB, CMYK, and Grayscale color modes. The settings also specify the color profile for spot colors in a document. Central to the color management workflow, these profiles are known as working spaces. The working spaces specified by predefined settings represent the color profiles that will produce the best color fidelity for several common output conditions.

Wraparound Lighting. Soft type of light that wraps around the subject, producing a low lighting ratio and open, well-illuminated highlight areas.

X-Sync Speed. The shutter speed at which focal-plane shutters synchronize with electronic flash.

Zebra. A term used to describe reflectors or umbrellas having alternating reflecting materials such as silver and white cloth.

Michael J. Ayers, PPA-Certified, M.Photog., Cr., APM, AOPA, AEPA, AHPA. Michael Ayers, WPPI's 1997 International Portrait Photographer of the Year, is a studio owner from Lima, Ohio. He has lectured about portraiture and his "album architecture" all across North America and has also been a featured speaker in Europe.

Fernando Basurto. Fernando Basurto is an accomplished wedding photographer who does business in the prestigious Newport Beach area. Fernando is a member of WPPI and has judged their print competitions and holds the APM and AOPA degrees. His work can be seen at www.elegantphotographer.com

Becker. Becker, who goes by only his last name, is a wedding photojournalist who operates a successful studio in Mission Viejo, CA. He has been a featured speaker at WPPI and has also competed and excelled in international print competition. Visit his website at www.thebecker .com, which features a photographers' resource section that details Becker's workflow, equipment used for his weddings, and a healthy list of his favorite links.

David Beckstead. David Beckstead has lived in a small town in Arizona for over 20 years. With help from the Internet, digital cameras, seminars, WPPI, Pictage, and his artistic background, his passion has grown into a thriving wedding-photography business. He refers to his style of wedding photography as artistic photojournalism.

Marcus Bell. Marcus Bell is one of Australia's most revered photographers. Bell's comprehensive portfolio of work clearly illustrates his natural flair and versatility. His work has been published in numerous magazines in Australia and overseas, including *Black & White, Capture, Portfolio Bride,* and countless other bridal magazines.

Clay Blackmore. Clay Blackmore is an award-winning photographer from Rockville, MD. He has been honored by the PPA and WPPI and is a featured presenter on the lecture circuit around the United States. He started out as Monte Zucker's assistant. Clay is a member of the prestigious CameraCraftsmen of America and is a Canon Explorer of Light.

Drake Busath, Master Photographer, Craftsman. Darke Busath, the owner of Busath Photographers, has spoken all over the world and has been featured in a wide variety of professional magazines. He operates a successful wedding and portrait studio, and in addition, Drake Busath has had Italy-on-the-brain since 1977 when he lived and worked for two years in Northern Italy. He returns two or three times every year to visit and get his "fix" of Italian images, cuisine and attitude adjustment.

Joe Buissink. Joe Buissink is an internationally recognized wedding photographer from Beverly Hills, CA. Almost every bride-to-be who picks up a bridal magazine will have seen Buissink's exceptional images. He has photographed numerous celebrity weddings, including Jennifer Lopez's 2002 wedding, and is a multiple Grand Award winner in WPPI print competition.

Mark Cafiero. Mark graduated from the University of Northern Colorado with a degree in Business Administration and now owns three photography businesses. These include Pro Photo Alliance, a turnkey online proofing solution for photo labs and other professional photographers, a College Event Photography company and his own wedding/event/portrait business.

Ron Capobianco. Ron Capobianco has been a professional photographer for over 25 years. His commercial

work has been seen in *Vogue, W, Glamour, New York, French Vogue, Harper's Bazaar,* the *New York Times,* and *Madam Figaro.* His wedding work has been seen in *Modern Bride, Bride's, Wedding Bells, Manhattan Bride,* and other bridal publications. He also has collaborated on several book projects including, *Eclectic Living: At Home with Bari Lyn* (Harper Collins, 1998) and *Hair: The Inter-Beauty Collection* (Intercommunication Magazine, 1979) by Elena Domo.

Anthony Cava, BA, MPA, APPO. Born and raised in Ottawa, Ontario, Canada, Anthony Cava owns and operates Photolux Studio with his brother, Frank. Frank and Anthony's parents originally founded Photolux as a wedding/portrait studio 30 years ago. Anthony joined WPPI and the Professional Photographers of Canada 10 years ago. At one time, he was the youngest Master of Photographic Arts (MPA) in Canada. Cava won WPPI's Grand Award for the year with the first print that he ever entered in competition.

Mike Colón. Mike Colón is a celebrated wedding photojournalist from the San Diego, CA, area. Colón's work reveals his love for people and his passion for life. His natural and fun approach frees his subjects to be themselves, revealing their true personalities and emotions. His images combine inner beauty, joy, life, and love frozen forever in time. He has spoken before national audiences on the art of wedding photography.

Cherie Steinberg Coté. Cherie began her photography career as a photojournalist at the *Toronto Sun* and had the distinction of being the first female freelance photographer for that paper. She was also honored with Canada's equivalent of the National Endowment for the Arts. Cherie currently lives in Los Angeles and has recently been published in the *L.A. Times, Los Angeles Magazine,* and *Towne & Country.*

Jim DiVitale, M.Photog, MEI, Cr, API, F-ASP. Jim DiVitale's award-winning digital photography has been featured in *Graphis Photo, Print, Archive, Creativity, Photo Electronic Imaging, Digital Output Magazine, Digital Imaging, Rangefinder,* and *Photo District News.* Jim has lectured before audiences at Seybold, Photo Plus, MAC Design, Imaging USA, HOW Design, WPPI, and World Council of Professional Photographers. His clients include IBM, BP Amoco, Mizuno USA, Genuine Parts Company, Witness Systems, JP Morgan Financial, TEC America, Coca-Cola USA, and Scientific Atlanta. See more of Jim's work at www.DiVitalePhoto.com

Don Emmerich, M.Photog., M.Artist, M.EI, Cr., CEI, CPPS. Don Emmerich is a virtuoso of the visual arts and one of the pioneers of applied photographic digital imaging. He belongs to a select group of professionals who have earned all four photographic degrees, and was chosen to be a member of the exclusive Camera Craftsmen of America Society, comprised of the 40 top portrait photographers in the United States. Don has been PPA's Technical Editor for the past 12 years, with some 150 articles published in various magazines, both nationally and internationally.

Jim Fender. Jim Fender is part of Fender Donisch Photography in Naperville, IL. Fender has won numerous awards including many local honors, Fuji Masterpiece awards, and Kodak Gallery Awards. He also has several prints on display at Epcot Center in Disney World as well as in the PPA Traveling Loan collection. His studio has won the Top Wedding Album for Illinois several times.

Jerry Ghionis. Jerry Ghionis of XSiGHT Photography and Video started his professional career in 1994 and has established himself as one of Australia's leading photographers. His versatility extends to the wedding, portrait, fashion, and corporate fields. Jerry's efforts were recognized in the industry, being honored with the 1999 AIPP (Australian Institute of Professional Photography) award for best new talent in Victoria. In 2002 Jerry won the AIPP Victorian Wedding Album of the Year, and in 2003 he won Wedding Album of the Year and also taking the Grand Award in the Album competition at WPPI.

Ann Hamilton. Ann Hamilton began her professional career as a journalist writing lifestyle stories for an East Coast newspaper. Now, as a photographer documenting weddings, Ann combines her love of photography with a journalistic sense and artistic flair. Ann's work was has been featured in *Wedding Bells* and *The Knot* magazines. She also won two honorable mentions at the WPPI International print competition, of which she is a member. She and her husband, Austin, along with their pug, Bogie, reside in San Francisco, CA.

Jeff and Kathleen Hawkins. Jeff and Kathleen Hawkins operate a high-end wedding and portrait photography studio in Orlando, FL. They have authored several books, including *Professional Marketing & Selling Techniques for Wedding Photographers* (2001) and *Professional Techniques for Digital Wedding Photography* (2nd ed., 2004), both published by Amherst Media. Jeff Hawkins has been a professional photographer for over

twenty years. Kathleen Hawkins holds a masters degree in business administration and is past president of the Wedding Professionals of Central Florida (WPCF) and past affiliate vice president for the National Association of Catering Executives (NACE). Visit their website at: www.jeffhawkins.com.

Glenn Honiball. Glenn Honiball is the ultimate Photoshop practioner. His clients are ad agencies—the most prestigious ones—from around the world. He has worked for the likes of: J. Walter Thompson, Optic Nerve, Brainstorm, Saatchi & Saatchi, and Zig, to name a few. Companies he's worked for include such big names as Ford, GE, BMW, Coke, Sony, Kraft Foods and the NFL. At this writing Glenn Honiball is working on a new book, *Commercial Photoshop Retouching: In the Studio* (O'Reilly, 2005). For a look at 80 of Glenn's befores and afters, visit his web site: www.retouch.ca.

Kevin Jairaj. Kevin Jairaj is an award-winning wedding and portrait photographer whose creative eye has earned him a stellar reputation in the Dallas/Fort Worth, TX, area. He is formerly a fashion photographer who uses skills learned in that discipline when shooting his weddings and portraits. His web site is: www.kjimages.com.

Claude Jodoin. Claude Jodoin is an award-winning photographer from Detroit, MI. He has been involved in digital imaging since 1986 and has not used film since 1999. He is an event specialist and also shoots numerous weddings and portrait sessions throughout the year. You can e-mail him at claudej1 @aol.com.

Jeff Kolodny. Jeff Kolodny began his career as a professional photographer in 1985 after receiving a BA in Film Production from Adelphi University in New York. Jeff recently relocated his business from Los Angeles to South Florida, where his ultimate goal is to produce digital wedding photography that is cutting edge and that sets him apart from others in his field.

Christian LaLonde. Chris is a native of Ottawa, Canada. After graduation from La Cite Collegiale, in 1996 he took a job in a commercial studio in Ottawa, shooting food. He later taught lighting for his alma mater and, while there, was approached by Anthony and Frank Cava of Photolux Studio in Ottawa about opening a commercial division within Photolux. He gladly accepted and now concentrates mostly on corporate, architectural, food, product, and editorial jobs. In 2002 and 2003 he was awarded the prestigious Canadian Commercial Photographer of the Year.

Kersti Malvre. After a long and successful career in the fashion and cosmetics industries, Kersti Malvre discovered the world of hand-painted photography. Since 1995, she has been devoted to this art form. She is now recognized as one of the top photographic artists in the country and holds the PPA Photographic Craftsman's degree for outstanding contributions to the portrait photography profession.

Charles and Jennifer Maring. Charles and Jennifer Maring own Maring Photography, Inc. in Wallingford, CT. Charles is a second-generation photographer, his parents having operated a successful studio in New England for many years. His parents now operate Rlab (www.resolutionlab.com), a digital lab that does all of the work for Maring Photography, as well as for other discriminating photographers in need of high-end digital work. Charles Maring is the winner of the WPPI 2001 Album of the Year Award. His work was recently featured in *People* magazine, which ran six pages of his images from the Star Jones wedding.

Leslie McIntosh. Continuing a family tradition into the new millennium, Leslie McIntosh represents a new generation of high-quality portrait artists. Recently returning to Virginia Beach to join the McIntosh family business, Leslie completed her Bachelor of Fine Arts degree from the Art Institute of Chicago, moving on to London and then Hamburg to build a successful career in the advertising and fashion photography business. She sensitively captures the mood of a subject's character, personality, and stage of life. Leslie has specialized in families, mothers and children, along with high school seniors, but is open to all markets.

Mercury Megaloudis. Mercury Megaloudis is an award-winning Australian photographer and owner of Megagraphics Photography in Strathmore, Victoria, Australia. The Australian Institute of Professional Photography awarded him the Master of Photography degree in 1999. He has won awards all over Australia and has recently begun entering and winning print competition in the United States.

Craig Minielly, MPA, SPA. Craig Minielly is the owner and operator of AURA Photographics, a totally digital photography studio servicing the Canadian market for the last 18 years. Craig is currently on the PPOC National Exhibition Committee and is the National Accreditation Chairman for PPOC. He is a three-time Ontario Photographer of the Year, British Columbia

Photographer of the Year finalist, and six-time Canadian Photographer of the Year finalist. His Photoshop actions are widely regarded as some of the best and most creative plug-ins available. His website is www.craigsactions.com.

Rich Nortnik, Jr. Educated in fine arts, Rich Nortnik, Jr. is considered to be one of the world's foremost experts in Photoshop. In the last five years, he has been awarded numerous design and digital- illustration awards and has even been christened an official "Photoshop Guru." As senior designer/illustrator for the Shaw Group, one of the world's largest engineering and construction firms, he has designed artwork and illustrations for transportation projects all over the world. Visit Rich Nortnik Jr.'s website at www.richnortnikjr.com.

Tim Schooler. Tim Schooler Photography is an award-winning studio specializing in high-school senior portrait photography with a cutting-edge style. Tim's outstanding work has been published internationally in magazines and books. His studio is located in Lafayette, LA. See Tim's outrageous portfolio of senior images at his website: www.timschooler.com.

Jeff Smith. Jeff Smith is an award-winning senior photographer from Fresno, CA. He owns and operates two studios in Central California and is well recognized as a speaker on lighting and senior photography. He is the author of *Corrective Lighting, Posing, and Retouching for Digital Portrait Photographers* (Amherst Media, 2005), *Senior Contracts* (self-published), and *Outdoor and Location Portrait Photography* (Amherst Media, 2003). He can be reached at www.jeffsmithphoto.com.

David Clark Wendt. After years of shooting traditional commercial work and stock photography, Cincinnati, OH, photographer David Clark Wendt has found his niche in self-publishing calendars of fast-moving and slick cars. He has also produced award-winning calendars on 18-wheelers and steam locomotives. An entrepreneur, Wendt started with the bare minimum print run of 5000 calendars and is now printing 40,000 a year. His work can be purchased in Borders and other popular bookstores. His work can be seen at www.wendtworldwide.com.

David Anthony Williams, M.Photog., FRPS, AOPA. David Anthony Williams owns and operates a wedding studio in Ashburton, Victoria, Australia. In 1992, he achieved the rare distinction of receiving Associateship and Fellowship of the Royal Photographic Society of Great Britain (FRPS) on the same day. Through the annual Australian Professional Photography Awards system, Williams achieved the level of Master of Photography with Gold Bar—the equivalent of a double master. In 2000, he was awarded the Accolade of Outstanding Photographic Achievement from WPPI and was a Grand Award winner at their annual conventions in both 1997 and 2000.

Jeffrey and Julia Woods. Jeffrey and Julia Woods are award-winning wedding and portrait photographers from Washington, IL, who work as a team. They have been awarded Best Wedding Album of the Year for 2002 and 2003, two Fuji Masterpiece awards, a Kodak Gallery Award, and Best of Show at the APPI fall convention. In 2002 and 2003, they were named Top Ten Photographers in Illinois. To see more of their beautiful images, just visit www.jwweddinglife.com.

David Worthington, L.M.P.A. David Worthington is a professional photographer who specializes in classical wedding photography. David is one of only two photographers in the northwest UK to have a wedding image published in a book celebrating the best professional photos from photographers over the last fifty years. This is indeed a fine achievement as only fifty images were selected from entries sent from around the world. Two of David's most recent awards include the 2003 Classical Wedding Photographer of the Year Award for the UK, Northwest Region, and 2003 Licentiate Wedding Photographer of the Year, UK, Northwest Region.

Yervant Zanazanian, M. Photog. AIPP, F.AIPP. Yervant was born in Ethiopia, lived and studied in Italy, then settled in Australia 25 years ago. His passion for photography and the darkroom began at a young age, when he worked after school at a photography business run by his father, photographer to Emperor Hailé Silassé of Ethiopia. Yervant owns one of the most prestigious photography studios of Australia and services clients both nationally and internationally. His awards are too numerous to mention, but he has been Australia's Wedding Photographer of the Year three of the past four years.

Monte Zucker. When it comes to perfection in posing and lighting, timeless imagery, and contemporary, yet classical photographs, Monte Zucker is world famous. He's been bestowed every major honor the photographic profession offers, including WPPI's Lifetime Achievement Award. In his endeavor to educate photographers at the highest level, Monte, along with his partner, Gary Bernstein, has created an information-based web site for photographers, www.Zuga.net.

INDEX

ARTISTIC TECHNIQUES WITH ADOBE® PHOTOSHOP® AND COREL® PAINTER®

Deborah Lynn Ferro

Flex your creative skills and learn how to transform photographs into fine-art masterpieces. Step-by-step techniques make it easy! $34.95 list, 8½x11, 128p, 200 color images, index, order no. 1806.

DIGITAL PHOTOGRAPHY BOOT CAMP

Kevin Kubota

Kevin Kubota's popular workshop is now a book! A down-and-dirty, step-by-step course in building a professional photography workflow and creating digital images that sell! $34.95 list, 8½x11, 128p, 250 color images, index, order no. 1809.

MARKETING & SELLING TECHNIQUES

FOR DIGITAL PORTRAIT PHOTOGRAPHERS

Kathleen Hawkins

Great portraits aren't enough to ensure the success of your business! Learn how to attract clients and boost your sales. $34.95 list, 8½x11, 128p, 150 color photos, index, order no. 1804.

PROFITABLE PORTRAITS

THE PHOTOGRAPHER'S GUIDE TO CREATING PORTRAITS THAT SELL

Jeff Smith

Learn how to design images that are precisely tailored to your clients' tastes—portraits that will practically sell themselves! $29.95 list, 8½x11, 128p, 100 color photos, index, order no. 1797.

PROFESSIONAL TECHNIQUES FOR

BLACK & WHITE DIGITAL PHOTOGRAPHY

Patrick Rice

Digital makes it easier than ever to create black & white images. With these techniques, you'll learn to achieve dazzling results! $29.95 list, 8½x11, 128p, 100 color photos, index, order no. 1798.

DIGITAL INFRARED PHOTOGRAPHY

Patrick Rice

The dramatic look of infrared photography has long made it popular—but with digital it's actually *easy* too! Add digital IR to your repertoire with this comprehensive book. $29.95 list, 8½x11, 128p, 100 b&w and color photos, index, order no. 1792.

LIGHTING TECHNIQUES FOR

FASHION AND GLAMOUR PHOTOGRAPHY

Stephen A. Dantzig, PsyD.

In fashion and glamour photography, light is the key to producing images with impact. With these techniques, you'll be primed for success! $29.95 list, 8½x11, 128p, over 200 color images, index, order no. 1795.

MASTER LIGHTING GUIDE

FOR PORTRAIT PHOTOGRAPHERS

Christopher Grey

Efficiently light executive and model portraits, high and low key images, and more. Master traditional lighting styles and use creative modi-fications that will maximize your results. $29.95 list, 8½x11, 128p, 300 color photos, index, order no. 1778.

POWER MARKETING FOR WEDDING AND PORTRAIT PHOTOGRAPHERS

Mitche Graf

Set your business apart and create clients for life with this comprehensive guide to achieving your professional goals. $29.95 list, 8½x11, 128p, 100 color images, index, order no. 1788.

POSING FOR PORTRAIT PHOTOGRAPHY

A HEAD-TO-TOE GUIDE

Jeff Smith

Author Jeff Smith teaches surefire techniques for fine-tuning every aspect of the pose for the most flattering results. $29.95 list, 8½x11, 128p, 150 color photos, index, order no. 1786.